THE
ART
OF
MODERN
JAPAN

THE
ART
OF
MODERN
JAPAN

Teshigahara Sofu
Abstract Sculpture
Showa Period.

From the Meiji Restoration to the Meiji Centennial

1868–1968

by

Hugo Munsterberg

Hacker
Art
Books
New York
1978

This book
is dedicated
to the memory
of my father
Oskar Münsterberg
who visited Japan
in the 32nd year
of Meiji
and my daughter
Marjorie
who was born
in Japan
in the 26th year
of Showa

Table
of
Contents

List
of
Illustrations

THE
ART
OF
MODERN
JAPAN

Preface

While there are many excellent books dealing with the history of Japanese art from pre-historic time to the end of the Edo period, there has been no general book on the art of what Professor Borton calls Japan's Modern Century. It is to this period that the present work addresses itself. Only in recent years have Japanese scholars begun to concern themselves with the history of their own modern art, especially that of the Meiji period. Even in Japan, however, art historians have usually either omitted the last hundred years, or have dealt with it in a brief concluding chapter. With the Meiji Centennial of 1968, the first serious attempts have been made to fill this gap, and it is to be hoped that more specialized studies of this art will now be undertaken.

Western critics and scholars have tended to neglect modern Japanese art because they felt not only that the work was inferior but that it had lost something of the authentic Japanese quality of traditional art. Be that as it may, the encounter between indigenous art and expanding Western culture is a world—wide phenomenon affecting China, India, Africa and the Islamic world as well as Japan. Hence the question of the future of Japanese art is of concern not only to the Japanese people but to all people of the non—Western world.

In dealing with this material, I have drawn not only on Japanese and Western literature but also on my personal experiences and encounters during an extended stay in Japan from 1952 to 1956 as well as a number of shorter trips to Japan in recent years. It was my privilege to see many of the masterpieces of modern Japanese art, to meet several outstanding contemporary artists, and to discuss the artistic developments of today with leading Japanese critics and scholars, all of whom were most interested in the future of Japanese art. My special thanks are due to my Japanese colleagues and friends, Professor Fumio Tanaka and Dr. Masakata Kanazawa of the International Christian University in Tokyo, and to Mr. Yasushi Egami and Miss Akiko Ueno of the Art Research Institute of Tokyo who assisted me in my research and in procuring photographs in Japan; and to my wife, Peggy Bowen Munsterberg, who, as on so many previous occasions, went over the manuscript with great care and made many helpful suggestions.

Hugo Munsterberg
New Paltz, New York
July 1974

Chapter 1
Japanese Culture During the Meiji Period

The event which inaugurated the dramatic changes that transformed Japan from a backward and isolated feudal country to the most advanced industrial nation of Asia is known as the Meiji restoration. *The New York Times* of December 15, 1868, carried the following account of this historic occasion: "The Mikado, who has been slowly and painfully emerging from the seclusion of centuries, like a butterfly from its chrysalis, has at length consummated the act, thanks to my lord Satsuma, and has celebrated it by a royal coronation. In the imperial city of Kioto at 8 o'clock A.M. on October 12th, year of grace 1868, the splendid farce was enacted, and the poor boy, born a priest and educated a woman, was dragged out to play the king for the pleasure of the Southern Daimios. It was admirable strategy on Satsuma's part, when he induced his ancient enemy the Tycoon, to retire from Kioto to Osaka, apparently to benefit the Empire, but really to get the imperial puppet into his (Satsuma's) own hands."

No one, probably least of all the emperor himself, realized what far-reaching effects these events would have not only on Japan itself but on the entire history of the world. The transfer of power to the emperor from the Tokugawa shoguns, who had ruled Japan for two and a half centuries, was soon followed by the Charter Oath and the opening of Japan to Western civilization, and within a generation the country had become totally different from what it had been ever since the ancestors of the Mikado had assumed their rule some two thousand years before. Only the Taika reform of 645 A.D. which remodeled Japan in the image of T'ang China had a similar impact on the nation. And at that time, as in the later period, the Japanese, although eager students of their foreign teachers, succeeded in absorbing much of the alien, more highly developed civilization without losing their identity as Japanese.

Born in 1852, the emperor as a boy was called Sachi, or Heavenly Grace, a name which was changed to Mutsuhito when he was declared an imperial prince in 1860. He came to the throne at the death of his father, the emperor Komei, in 1866. In accordance with Japanese custom, upon his ascension to the throne and following his investiture in sacred ceremony with the three divine regalia of sovereignty, the mirror, the sword and the crystal sphere, a new name was given to his reign: Meiji, or the Enlightened Rule. In the eyes of some historians, such as W.E. Griffis, ". . . it was destined to be the most brilliant in all the annals of Japan."[1] The emperor's own message to his people already conveyed much of the spirit of the period. He said, "On ascending the throne of Our Ancestors, Our determination is, in spite of all difficulties that may beset our path, to rule our country in person, to secure the peace for all our subjects, to open friendly relations with other countries, to make our country glorious, and to establish the nation on a permanent basis of prosperity and happiness." Crowned in Nijo castle in Kyoto, in October 1868, the following spring Mutsuhito moved the imperial capital to Edo, renamed Tokyo, or Eastern capital, and set up his court in the Edo castle. It was here that the new emperor received Prince Alfred of England, later Duke of Edinburgh, and it is from this palace that the emperor's son and grandson have ruled the Japanese nation ever since.

During the next two decades Japan was seized by a frenzy of enthusiasm for everything Western and the old cry, "Away with the Western Barbarians!" that had been raised during the last days of the Tokugawa regime, was no longer heard. The speed of this devel-

opment was amazing. In 1869 telegraphic communications were opened between Tokyo and Yokohama; in 1871 a postal system modeled on Western lines was inaugurated; in 1872 the Western calendar was adopted, the first national bank was founded, the first railroad between Shimbashi station in Tokyo and Yokohama was started, the first gas lamps were put in the streets of Yokohama, and the first shipping line was founded. The Ginza street was reconstructed with brick buildings in 1873; the following year photography was introduced and at once became very popular. In 1877 Tokyo Imperial University was established, in 1889 the constitution was promulgated, and the following year the first Diet was opened, an event that confirmed Japan's status as a modern nation.

Among those responsible for this drastic transformation were not only Japanese statesmen and scholars but many Westerners who were invited to contribute their skills and knowledge to building a new Japan. The first of these were Dr. Willis, the British surgeon, and Ernest Satow, later Britain's plenipotentiary in Japan and China. These men were followed by a host of others. It is estimated that some 5,000 people, many of them Americans, came to help Japan between 1868 and 1900. Among the most famous were the English architect Josiah Conder, who came in 1876; the American zoologist Edward Morse, who arrived in 1877 and became a pioneer in the field of Japanese archaeology; and the German physician, Dr. Edwin Baltz, who introduced Western medicine to Japan. However, in regard to art, by far the most influential foreigner was Ernest Fenollosa (1853–1908), who was invited to teach philosophy and economics at Tokyo University, but functioned primarily as a critic and historian of art.

Other foreign teachers also exerted a profound influence on the arts of emerging Japan. The first was a retired British army captain, Charles Wirgman, a special correspondent of the *London Illustrated News* in Yokohama. Although not an accomplished artist, he introduced his pupils to the techniques and conventions of Western art. Far more influential were three Italians who were invited to Japan to become teachers at the newly established Kobu Bijutsu Gakko, or Technological Art School, which opened in 1876. Antonio Fontanesi, a painter of some distinction who since 1869 had been professor at the Royal Art School in Turin, was placed in charge of the painting program. He made a great impression on his Japanese pupils with his strong personality as well as his talent as an artist. Unfortunately he became ill and was forced to return to Italy at the end of 1878. The teacher in charge of sculpture was Vincenzo Ragusa, a gifted young artist who had an enormous influence on Japanese art since prior to his arrival the Japanese had only known Buddhist carvers and doll makers, neither of whom were regarded as true artists. The third was Cappelletti, a minor artist who taught courses in geometry, perspective and decoration. The impact of these European teachers was tremendous. Art students not only had their first chance to study under foreign teachers but they were also exposed to reproductions of great works of Western art and were able to use materials imported from Italy at government expense. Among the sixty students comprising the first class there were six girls — which at that time was a revolutionary innovation in itself. Another bold step, previously unknown in Japan, was the use of nude models, including a young girl who was persuaded to pose by being told that the students wanted to paint her because she was so beautiful.

While some artists worked with foreign teachers, others went abroad to study Western art in Europe. The first was Kunisawa Shinkuro, a member of the Tosa clan, who was sent to London in 1875 to study politics but instead studied oil painting. Another early student of Western art was Momotake Kaneyuki, a Japanese diplomat stationed in London during 1876, who studied painting in his spare time. A canvas of his, representing an English woman in Japanese dress, was exhibited in the Royal Academy. Others studied in Italy, like Kawamura Kiyoo, or in Germany, like Harada Naojiro. By far the most important of these pioneers was Kuroda Seiki (1866–1924) who worked under Raphael Colin in Paris from 1884 to 1893. Seiki belonged to an old aristocratic family from Satsuma and was a man of great talent and strong character. Upon his return from France, he founded a private art school in Tokyo where he instructed many young pupils. As a member of the Imperial Art Commission, president of the Imperial Art Academy and professor at the Tokyo School of Fine Arts he exerted an enormous influence on modern Japanese art and today is rightly regarded as the greatest figure among Western-style painters of the Meiji period.

Enthusiasm for Western art and all things Western became a veritable craze during the early Meiji period. In Tokyo, especially, there was a widespread feeling that to be Western was to be civilized. This sentiment was probably best expressed by the well known educator and polemicist Fukuzawa Yukichi (1834–1906), the founder of Keio University and editor of a Tokyo newspaper, who said, "To abstain from intercourse with foreign nations' is against the laws of nature and human nature."[2] Although the deeper levels of Western civilization were not yet understood, all its superficial aspects were imitated with eagerness. Men cut their hair, and both men and women started to wear Western clothes. Wristwatches enjoyed great popularity, and the Japanese began to eat beef and drink liquor. The extreme to which this craze was carried is best illustrated by the fact that it was seriously suggested that the trees surrounding the imperial palace be cut down and the pagoda of Kofu-ku-ji in Nara be sold for a few yen to be turned into scrap.

Inevitably, there was a counter-reaction to this slavish imitation of everything foreign. Strangely enough, the spokesman for this sentiment was not Japanese, but the American scholar, Fenollosa. Soon after his arrival in 1878, he took up the study of traditional Japanese art and at once developed a real interest and appreciation, especially for Buddhist art and the painting of the Kano school. He lectured on the superiority of Japanese painting and sculpture, and urged the Japanese to remain faithful to their artistic heritage instead of rushing to imitate foreign models. He also founded the Kyuchi Society for the furtherance of traditional Japanese art, advocated the establishment of a school of fine arts, encouraged Japanese-style artists and arranged art exhibitions and public lectures. In all these endeavors Fenollosa proved successful and he exerted a powerful influence on contemporary Japanese thought. In fact, it is safe to say that no foreigner ever had a greater influence in Japan. Not only in Japan itself but perhaps even more so in America and in Europe, this Boston scholar was the most persuasive spokesman for the unique beauty of Japanese art.

In his efforts to popularize traditional art, Fenollosa was helped by a brilliant young associate, Okakura Kakuzo (1862–1913), who first joined him as a student and interpreter and later became his colleague. In 1884, when Okakura was only twenty-two years old,

he was appointed by the Japanese government to serve with Fenollosa on a committee to study art education, and in 1886 they were sent abroad to study art education methods in the leading countries of the West. Upon their return, they published a report recommending that Japan concentrate on developing and furthering its native arts. This led to the founding of the Tokyo School of Fine Arts in 1889, which offered training only in traditional Japanese art. In addition to Fenollosa and Okakura, the faculty included two painters of the Kano school, Kano Hogai and Hashimoto Gaho, leading Japanese-style painters of the day. Their aim was to develop an art combining Eastern spirituality with Western techniques, notably through the use of perspective and modeling in light and shade. Okakura, who was extremely energetic and had a forceful personality, had a great influence as a teacher and a writer. In 1888 he founded *Kokka,* the first learned journal devoted to art, and ten years later he established the Japanese Academy of Art whose purpose was to propagate the new Japanese art.

In spite of Okakura's familiarity with Western art and culture and his complete command of English (*The Book of Tea,* his most famous work, was actually written in English), he was a staunch advocate of an Asian orientation for Japanese art, and he even traveled to China and India to establish contact with these other ancient civilizations of the East. His point of view is perhaps best expressed in a quotation from his book, *The Awakening of Japan.* "With immense gratitude to the West for what she has taught us, we must still regard Asia as the true source of our inspiration. She it was who transmitted to us her ancient culture, and planted the seed of regeneration. Our joy must be in the fact that, of all her children, we have been permitted to prove ourselves worthy of the inheritance. Great as was the difficulty involved in the struggle for national reawakening, a still harder task confronted Japan in her effort to bring an Oriental nation to face the terrible exigencies of modern existence."[3] While Okakura thought that a transformation of Japan was necessary and desirable in order to meet the conditions of the modern world, he also believed that she should remain true to her own heritage, or as he put it, "though our sandals changed, our journey continues."[4]

The struggle Fenollosa and Okakura undertook to preserve the artistic treasures of Japan and to reawaken the pride of the Japanese people in their own heritage led to the founding of the Tokyo National Museum in 1882, and to the Committee for the Protection of Cultural Properties, whose function was to conserve and protect the great Japanese artistic heritage. However, their efforts to bar the teaching of Western art were not successful; in fact, in 1896 its growing popularity forced the Tokyo School of Fine Arts to introduce oil painting in its curriculum, and Kuroda Seiki and Kume Keiichiro, two well-known Western-style painters, were appointed to the faculty. So popular did this art become that the number of students working in Western-style painting, called Yoga, was larger than that studying Nihonga, or Japanese-style painting.

In 1890 Fenollosa, whose influence had been declining in Japan, returned to the United States where he became curator at the Boston Museum of Fine Arts and wrote his *Epochs of Chinese and Japanese Art,* published posthumously in 1912. Okakura succeeded him as the director of the Tokyo Bijutsu Gakko. Oka-

kura tried to impress his ideas on the art school, but in spite of his colorful personality and pedagogical brilliance he was forced to resign in 1898, after a scandal rocked the school. This in turn led to the resignation of the majority of the Nihonga faculty. Okakura and his supporters immediately founded the Nihon Bijutsu-in, or Japan Art Academy, but he never regained the prominent position he had once enjoyed. During a trip to America he became friendly with Mrs. Jack Gardner of Boston, the well-known art patron, and he was appointed curator of Oriental art at the Boston Museum in 1906. Although he made frequent trips to Japan, he remained in the United States until his death in 1913. Okakura became very famous in America as an author and lecturer on Japanese aesthetics, and with Fenollosa he was responsible for making the collection of Oriental art at the Boston Museum the largest and best in the Western world.

The two events which dominated the later part of the Meiji period were the Sino-Japanese war of 1894–95 and the Russo-Japanese war of the next decade, which established Japan as a major military and naval power. The annexation of Formosa in 1895 and of Korea in 1910 transformed Japan from a nation of almost total isolation to one of dominant power in little more than one generation. Strangely enough, the result of the wars, which had aroused tremendous national enthusiasm, was to strengthen the hold of Western-style art on the Japanese people. Dramatic war scenes and the glorious military and naval victories were recorded in numerous prints, both traditional wood engravings and Western-style lithographs, as well as in large oil paintings executed in a realistic European style. Some of the battle scenes are so vivid in their naturalism that one would take them for Western paintings were it not for their subject matter and the signature of the artist. Among the many able artists who produced this type of work, by far the most distinguished was an early pupil of Charles Wirgman, the printmaker and painter Kobayashi Kiyochika (1847–1915) who introduced Western-style light and shadow into Japanese color prints. That such a period of intense nationalism should be accompanied by a growth of Western artistic influence is not surprising, for as former Prime Minister Yoshida said, "Once Japan plunged into the task of modernization such formulas as 'Eastern morals and Western art' or 'Japanese spirit and Occidental learning' were found to be ineffective, for the simple reason that civilization or culture is an indivisible whole. It is not possible to embrace only the scientific and technological aspects of it and exclude the rest."[5]

The ascendancy of Western ideas was not restricted to the visual arts, for literature and music, philosophy and religion, science and education all experienced similar developments during these decades. In 1885 Tsubouchi Shoyo published his *Essence of the Novel*, the first important critical work of modern Japanese literature. As Donald Keene points out, "The preface of the book threw the challenge in the faces of Japanese authors and readers alike: the sorry state of Japanese literature was no less the fault of readers who buy the sensational, pornographic fiction than the men who wrote the books."[6] Tsubouchi's challenge was more impressive than either the full statement of his views or the original works he wrote later on. His critical opinions were for the most part those of foreign writers applied by him to Japanese works. For example, Tsubouchi rejected the didactic novel, represented in Japan by such writers as Bakin, in favor of the artistic novel, whose beauty is its own excuse for being. Quotations from Sir Walter Scott, Thack-

eray, and other nineteenth—century giants buttress his arguments.[7] These new ideas found their first expression in Fubatei Shimei's novel of 1888, *The Drifting Cloud,* written entirely in colloquial Japanese and dealing with contemporary subject matter. Similar developments also occurred in the theatre with the rise of Shimpa, a new kind of realistic drama concerned with current events such as the Sino—Japanese war.

Even more striking were the changes occurring in general culture, changes which were no doubt enhanced by the introduction of compulsory education in 1872 and the establishment of numerous public and private universities. Other forces which helped to create a new Japan were the founding of a great variety of newspapers and magazines and the publication of innumerable books, including translations of Western works. Another factor which was to have a profound effect on all Japanese culture was the lifting of the ban on Christianity and Christian missionaries, in force since the early seventeenth century. Not only Catholic but now also Protestant missionaries and teachers came to Japan to preach the gospel and to establish Christian educational and charitable institutions which have had far more influence on Japanese society and culture than their relatively few converts. Modern Japanese culture with its humanistic and social ideals owes a great deal to these Christian teachers of the Meiji period, and many of the leading schools and universities of Japan, founded under Christian auspices, have been instrumental in spreading the knowledge and influence of the Western Christian civilization.

Chapter 2
Japanese Culture During the Taisho and Showa Periods

The death of the Meiji emperor in 1912 marked the end of a period of unprecedented change and development. In many ways the new reign represented a continuation of the old, but just as the Edwardian age differed from the Victorian, so the Taisho period (1912–26) had its own characteristics. The most outstanding were the increased liberalism and growing Westernization. The earlier part of the period roughly corresponds to the First World War (1914–18), in which Japan as an ally of Great Britain sided with the Western powers, a position which did not involve her much in actual combat but enabled her to develop her industries and to seize some of the German possessions in the Pacific. It also meant that Japan, as one of the victorious nations, participated as an equal at the peace conference of Versailles, and became a member of the newly established League of Nations. The Washington Naval Conference of 1921 set Japan's navy at a ratio of 3 to 5 in relation to those of Great Britain and the United States. These and other post-war developments greatly accelerated Japan's emergence as a world power.

The spirit of the new period was perhaps best exemplified by Crown Prince Hirohito's trip to England and France in 1921, the first instance of foreign travel by a member of the Imperial Family, and the reciprocal visit of the Prince of Wales to Japan, where he was received with great cordiality. In the large cities, especially in Tokyo, new personal styles appeared. One was called the "Marx boy." According to Richard Storry, "he was a left-wing student, often from an aristocratic or wealthy home, who excited his contemporaries and shocked his elders by his revolutionary views. There were to be seen, in sophisticated circles at any rate, the first signs of what was to be known as the Moga style. Moga was the Japanese

contraction of the English words "modern girl." It came to suggest during the twenties cloche hats and short skirts, with the "bob," "shingle," or even "Eton crop!" Her male counterpart was the Mobo, the modern boy (not to be confused with the "Marx boy" who on leaving the university, adopted the latest and most flashy Western clothes, including, sometimes, "Oxford bags"). Occasionally Mobo and Moga might be seen walking down the Ginza in Tokyo hand in hand. This was daring, but it was done."[8]

The trend towards greater liberalism and more democracy, which resulted in universal suffrage for males at the age of twenty-five and a commoner becoming prime-minister, was strengthened by the newspapers and magazines. The largest dailies such as *Mainichi* and *Asahi* had circulations of several million and exerted an enormous influence. Since they included essays, poems and installments of novels in addition to news, they had a far greater cultural influence than comparable papers in the United States. The magazines enjoyed large circulation and published radical thinkers like H. G. Wells and Bertrand Russell as well as their Japanese equivalents. The novels of the Taisho period are marked by an increased naturalism based on Russian and French models rather than the English ones which had been more influential during the Meiji period. Among the writers who emerged during the twenties, the greatest was no doubt Tanizaki Junichiro whose *A Fool's Love* of 1925 shows a notable psychological subtlety and a sensitive understanding of the ambiguous reaction of the Japanese to Western things. Other novels had a decidely left-wing slant such as Kobayashi Takiji's *The Crab Canning Boat* of 1929.

In the visual arts, the trend towards ever greater Westernization was accelerated by the earthquake of 1923

that destroyed most of Yokohama and practically all of downtown Tokyo. The new city which rose on the ruins of the old Edo contained many Western-style buildings of brick and concrete, some of them higher and more modern than anything previously seen in Japan. In painting, modern Western-style pictures became even more popular, among both the artists and the public. In 1928 the Imperial Fine Arts Academy Exhibition received 2837 entries in the Western style compared to 2107 in the Japanese style. Of these, 456 in the foreign manner and only 316 in the Japanese style were accepted. By the next year, the Yoga entries had climbed to over 4000 while the Nihonga entries dropped to less than half that number. The same situation prevailed in the Tokyo School of Fine Arts, where in 1920 ten times as many students as could be admitted applied for Western-style painting classes while the Japanese painting classes could not be filled.

The Taisho period ended with the death of the emperor in December 1926. His son Hirohito, who had been regent during his father's illness, succeeded to the throne. The new era was called Showa, meaning Enlightened Peace, and for a while, at least, this name seemed appropriate. The young emperor was a moderate and a humanist with a scientific bent whose real interest was marine biology. But despite the apparent prosperity and political liberalism, storm clouds were gathering. In Italy and Germany the forces of nationalism and militarism were rising, and with the world–wide depression of the late '20's and early '30's Japan suffered economic hardships, especially among the peasants, and general discontent. In 1930 ultra–rightists made an attempt on the Prime Minister's life, and army officers, increasingly restless, began to plot military adventures in China. The subsequent events are

well known, from the conquest of Manchuria in 1931 to the attack on Pearl Harbor and the outbreak of the Pacific war. The initial victories and final defeat and occupation of Japan are too familiar to bear recounting.

That the turn from the liberal international outlook of the '20's to the feelings of intense nationalism and racial superiority was not restricted to the fanatical ultra-rightists but enjoyed widespread support among the masses and many of the intellectuals is best seen in the cultural developments of that period. Tanizaki, a student of English literature whose early work was profoundly influenced by Western novels, became increasingly absorbed in the Japanese past. Glorifying the traditional aesthetic sensibility in his famous essay of 1934, "In Praise of Shadows," he contrasted the restless modern world with the beauty and calm of the traditional Japanese way of life. As Edward Seidensticker says in speaking of Tanizaki's novel, *Some Prefer Nettles,* "The issue is clearly drawn . . . to be foreign is to court unhappiness, a Japanese can find peace only by being as intensely Japanese as the times will allow."[9] This concern with the Japanese tradition is also apparent in *The Distinctive Character of Japanese Art,* by Japan's leading art historian, Yashiro Yukio. Like Tanizaki, Yashiro was previously well known for his international outlook, best exemplified by his book on Botticelli. The same trend is also found in the visual arts, with Nihonga playing an increasing role and the greatest contemporary Japanese–style painter, Yokoyama Taikan, painting over and over the majestic form of Mount Fuji, the sacred emblem of the Japanese people.

In contrast to moderates like Tanizaki, who merely wished to reaffirm the values of traditional Japanese

culture, were the strident voices of the super-patriots, of whom Kita Ikki, often called the founder of Japanese fascism, was the most blatant. Urging an expansionist policy abroad and advocating a military coup to reconstruct Japan along dictatorial and military lines, Kita foreshadowed the developments under the war–time prime minister Tojo. Characteristic of this trend was a pamphlet, *Fundamentals of Our National Policy,* published by the Ministry of Education in 1937, which sold two million copies. In this work all the evils of contemporary Japan were blamed on foreign ideas, while the true basis of the Japanese tradition was said to rest upon the divine emperor, the fountainhead of the life of the Japanese nation.[10]

The defeat of Japan in 1945 brought an end to this period of nationalism and militarism and overnight the leaders of the country were discredited. The forces of liberalism and democracy re-emerged, and the new constitution, the introduction of women's suffrage and the rejection of military force as a means of settling international disputes completely changed the climate of opinion, as did the American occupation of 1945–1952. For the first time large numbers of Japanese came into direct contact with Westerners, and there is no doubt that this further increased the Westernization of the country.

The signing of the peace treaty and the admission of Japan to the United Nations hastened Japan's return as a respected member of the family of nations. Her phenomenal economic recovery, which soon made her the leading industrial nation in Asia, was even more remarkable, and when celebrating the hundredth anniversary of the Meiji Restoration in 1968, the Japanese people could point with pride to the transformation of a backward Asian country to a modern industrial nation in little more than three generations.

The best illustrations of this change are the award of the Nobel Prize of 1949 to a Japanese physicist and the development of the super-express trains between Tokyo and Osaka, surpassing anything developed in America or Europe. Writers such as Kawabata, Tanizaki and Mishima now command a world audience, and Japanese movies, especially those of Kurosawa, enjoy international acclaim. In the visual arts, too, the post-war period was one of growth and achievement; Tokyo became second only to Paris and New York as a world art center and architects like Tange and Maekawa are ranked with the best in the world.

Chapter 3
Modern
Japanese
Style
Painting

During the late Edo period, many of the traditional schools of painting were still active, but most of their work was inferior to that of earlier times. The greatest painters of the period, Uragami Gyokudo (1745–1820), Watanabe Kazan (1797–1841), and Sakai Hoitsu (1761–1828), had died some time before the Meiji Restoration, and the last great master of Ukiyo-e, Ando Hiroshige (1797–1858), did not live to see the coming of the new era. Western influences had penetrated into Japan during the eighteenth century, and continued to increase all through the late Edo period, profoundly affecting even traditional painters, notably those of the Maruyama School.

There were a number of active groups of painters at the end of the Edo period and the beginning of the Meiji; the most important was the Maruyama Shijo school in Kyoto, the ancient capital. It was founded by Goshun (1752–1811). Maruyama Okyo (1735–1795), who gave his name to the school, was another leading figure. He combined the decorative tradition of Japanese painting with more realistic conventions derived from European art and late Ming painting. Another influential group were the literati, or Bunjinga artists of the Southern, or Nanga school. They based their work on the Chinese gentlemen-painters of the late Ming and early Ch'ing period, and used a rather abstract brush style.

In Tokyo, many different schools of painting existed side by side. The most popular was the Ukiyo-e school of genre painting and wood engraving, whose scenes from the Kabuki drama and the life of the Yoshiwara district were typical of nineteenth-century Edo. The Kano school, with its Chinese-style ink paintings, the Rimpa school based on the colorful, decorative pictorial compositions of Sotatsu and Korin, the Tosa school derived from Yamato-e narrative scrolls of the Heian and Kanakura periods, and the school of Buddhist temple painting, were all working in Tokyo during the second half of the nineteenth century.

The entire art world of Japan, with its varied artistic points of view, was profoundly affected by the opening of the country in the 1860's. In 1876 a Western-style art school was established, with foreign teachers introducing novel methods of painting. The outstanding event in the world of Japanese art at this time was the arrival of Ernest Fenollosa in Tokyo in 1878. Fenollosa began his teaching career in Tokyo as an advocate of the introduction of oil painting, but soon became an ardent supporter of traditional Japanese art: ". . . it was Fenollosa who really inaugurated modern Japanese-style painting."[11]

The people Fenollosa chose for this rebirth were two painters of the Kano school, Kano Hogai (1828–1888), and Hashimoto Gaho (1835–1908). He dreamed of combining the use of light and shadow, or notan, with the vigorous and expressive line which he saw as the very essence of Eastern painting. The result would be an art preserving the best of both Oriental and Western traditions, inspiring Japanese painting with new life. Hogai, an accomplished master of the Kano school, had early been interested in Western-style painting. Fenollosa discovered his work at the Second National Painting Exhibition of 1884, and encouraged the maturation of his style. The relationship between the two men grew as Fenollosa tried to recreate in Hogai all his artistic aspirations. Hogai responded

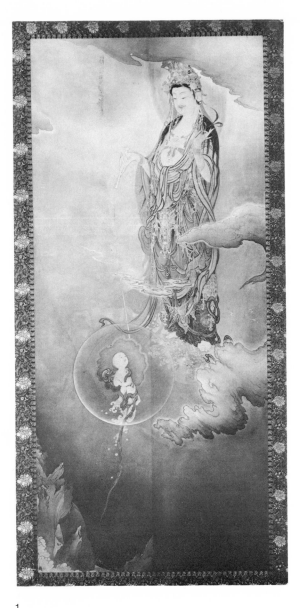

1
Kano Hogai
Kannon. Meiji Period.

with great enthusiasm, and produced such fine works of Meiji painting as "Giant Eagle" and "Hibo Kannon," both done in 1888 and now in the collection of the Tokyo University of the Arts (plate 1). His works appear in many collections (plate 2); the finest example in America is the Kanzan and Jittoku painting in the Freer Gallery (plate 3).

Upon his death at the age of sixty when his remarkable powers were just emerging, his place was taken by his friend and colleague at the Tokyo School of Fine Arts, Hashimoto Gaho. A more moderate man than Hogai, in both personality and artistic orientation, Gaho modified his predecessor's bold style. While Hogai stressed a vigorous line, Gaho put more emphasis on color and tone, as is evident in his "Mountain Landscape," also of the Freer Gallery. His basic aim, like that of Hogai, was to revitalize the Kano tradition by infusing it with some of the more realistic conventions of Western art.

Considerable disagreement exists over these artists' contributions to the development of Japanese art. Some critics have agreed with Fenollosa and Okakura in placing them among the masters of Japanese painting, and in crediting them for the great revival of the traditional style which has taken place in modern times. Others see their attempt to combine Eastern and Western traditions without fusing them into a completely new style as a hopeless task doomed from the very start. This clash of opinion is most evident in the assessment of Hogai's celebrated "Hibo Kannon." Some critics have called it a masterpiece. Others find that the yoking of traditional Buddhist conceptions and artistic conventions to a somewhat far-fetched original iconography and Western artistic devices results in a work which is neither traditional nor mod-

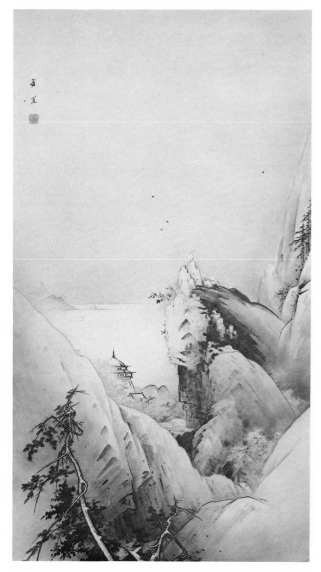

2
Kano Hogai
Landscape. Meiji Period.

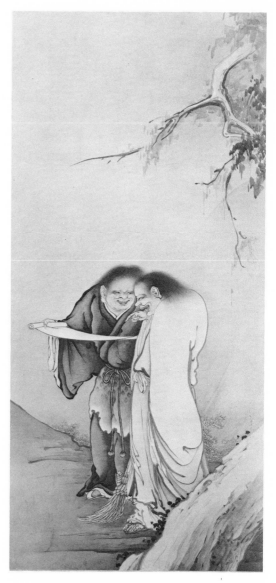

3
Kano Hogai
Kanzan and Jittoku. Meiji Period.

ern, the two divergent styles existing side by side rather than fusing into a new unified style. In his essay, "Western-Style Painting of the Early Meiji Period," John Rosenfield expresses this point of view very well: "The sentimental buoyant revivalism of Fenollosa and Okakura was both an indisputable act of affirmation and a futile gesture of defiance in affirming the grandeur of past achievement while denying the Western-style artists their right of expression. Unrealistic also were their attempts to revive ancient arts in a totally different order of society and technology. Okakura and Fenollosa could only deplore the mighty corrosive forces of industrialism; their intellectual weapons were not adequate to the task of controlling them."[12] No matter how the work of Hogai and Gaho is evaluated aesthetically, their place in the development of Japanese-style painting is secure.

Tomioka Tessai (1837–1924), a contemporary of Hogai and Gaho, remained totally unaffected by Western influences and ultimately proved himself a far greater artist than either of the innovators. Born in Kyoto into an old merchant family, Tessai was trained in Chinese and Japanese classics and was a Shinto priest as well as a man of letters. He was a member of the Bunjinga school, for which Fenollosa had nothing but contempt. Tessai regarded himself primarily as a man of learning and a teacher of Chinese literature, rather than as a professional painter. He was a conservative who had little contact with the new trends spreading across Japan during his mature years. He was the last, and in the eyes of some critics the greatest, flowering of the old Oriental tradition. Precisely because Tessai did not try to achieve a compromise between two exclusive worlds, his art is purer and more successful than that of his contemporaries in the Kano school (plate 4).

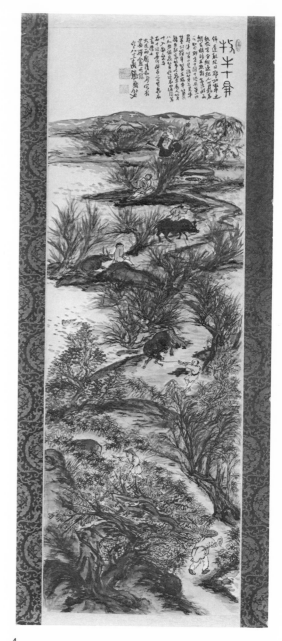

4
Tomioka Tessai
Jugyu-zu. Meiji Period.

Tessai's early work, done from his twenties to the age of fifty, adhered closely to the style of the Chinese painters of the Southern school. The masters of this school used Chinese ink and specialized in landscape painting, producing some of the greatest works of Chinese painting, and were much admired by Japanese scholars and gentlemen-painters. These early paintings have little of the boldness and originality for which Tessai's later work is known and do not belong among his most important paintings. His genius did not manifest itself until his later years, and reached its climax only in his seventies and eighties. As Odakane Taro says in his excellent study of Tessai: "Those who reach artistic maturity and produce their finest paintings very late in life, such as Tessai, however, are exceptional . . . Tessai's brush work grew more dynamic and his colors increasingly fresh and spontaneous. His compositions became crisper and more taut, and his own individual, instinctive style became clearer. Indeed, it may be stated with confidence that his paintings of this period display a perfection which is in no way inferior either to the work of the great Chinese Literati-style painters, such as Tung Cho'i-ch'ang, Pa-ta Shan-jen and Shih-t'ao, or famous Japanese masters of the school such as Taiga and Gyokudo."[13] This later work does indeed resemble that of the Eccentric Painters of the early Ch'ing period, both in style and in spirit, and many of Tessai's subjects are taken from Chinese history and legend.

Tessai worked very rapidly and produced a huge oeuvre estimated at some thirty thousand works. It has been reported that on one single day in 1894 he painted no less than seventy pictures of various sizes, and at the end of his life, when he was almost ninety, he was still doing some of his best work. The work of Tessai's old age, although often somewhat crude, has

5
Tomioka Tessai
Dragon. Showa Period.

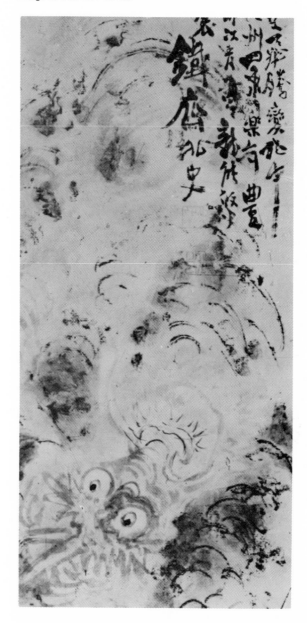

a bold expressiveness unique in modern Japanese-style painting. In contrast to the few forms in empty space which characterize the work of other modern Japanese-style painters, Tessai seemed to revel in vigorous brush strokes crowding the entire space, creating a remarkable dynamic power. This is evident in his dragon painting in the collection of the Tokyo National Museum (plate 5). Using heavy strokes, washes, blots of ink and rich coloristic effects, his pictures often resemble those of modern Expressionists. His work enjoys great popularity, in the West as well as in Japan.

The rebirth of Japanese painting, inaugurated by Hogai and Gaho during the early Meiji period, achieved its fullest development in the later Meiji and Taisho periods when several of the outstanding Nihonga painters produced their best work. The dominant figure, and in the eyes of many critics the greatest, was Yokoyama Taikan (1868–1959). Born in the year of the Meiji Restoration, Taikan's life spans almost the entire modern period and his work is the most representative of Japanese-style painting. Coming from a military family in Mito and educated in Japanese traditions, Taikan remained faithful to his heritage despite the fact that he went abroad several times, visiting India, America, China and Italy. He always wore traditional Japanese dress, even in foreign countries, and it is said that he never sat on a chair. A pupil and later a colleague of Okakura's at the Tokyo School of Fine Arts, he was deeply influenced by his master's teachings and resigned from the school when Okakura was dismissed in 1898. His brilliant artistic career culminated in his appointment as artist to the Imperial Household in 1931. He was the first recipient of Japan's Cultural Medal, the highest honor awarded to an artist in Japan.

Although trained by Gaho in Chinese-style ink painting, Taikan also mastered the more typically Japanese tradition of colorful, decorative art derived from the screen painters of the Momoyama period and the masters of the Rimpa school. His output was tremendous, encompassing all types of painting, from long narrative scrolls to decorative screens, hanging scrolls, and panel paintings. Among his many outstanding works, the one which made the greatest impression was his "Wheel of Life," a long narrative scroll measuring 130 feet. While this work is executed in ink, other major works, like the pair of colorful screens called "Cherry Blossoms at Night" are obviously derived from the more typically Japanese tradition. His subjects are usually taken from Chinese or Japanese history and literature, with such time-honored themes as the "Eight Views of the Hsiao and Hsiang Rivers" and depictions of Mt. Fuji among his favorites (plate 6). An ardent Japanese nationalist, in 1941 Taikan painted "The Resplendent Isles," which was presented to the Emperor to commemorate the 2600th aniversary of the founding of the empire.

Two of Taikan's friends and colleagues at the Tokyo School of Fine Arts and the Japanese Institute of Art were also outstanding artists—Shimomura Kanzan (1873–1930), and Hishida Shunso (1874–1911). Both trained at the Tokyo School of Fine Arts in the Kano style and were students of Okakura. Like Taikan, they moved beyond the style of their teachers, turning

from the linear emphasis of the Kano masters to the more decorative aspects of Japanese painting. Their style represents a synthesis of various tendencies of traditional Japanese painting and forms the basis of all later development in modern Japanese-style work.

Shunso was a delicate, lyrical painter using subdued colors and graceful lines. Many of his subjects were taken from Buddhist legend. His finest work, designated as an Important Cultural Property (plate 7), was a decorative screen, "Fallen Leaves," of 1909. His early death, at the age of thirty-six, cut short a brilliant career.

Kanzan, trained like Shunso in Kano-style ink painting, soon found Japanese traditions better suited to his temperament. The works which critics regard as Kanzan's best are pairs of six panel screens which combine vigorous line with flat, decorative colors, among them "Autumn in the Forest," a typically Japanese fall landscape (plates 8, 9, 10). Also well known is his portrait of his friend and teacher, Okakura Tenshin.

6
Yokoyama Taikan.
Mt. Kisen. Taisho Period.

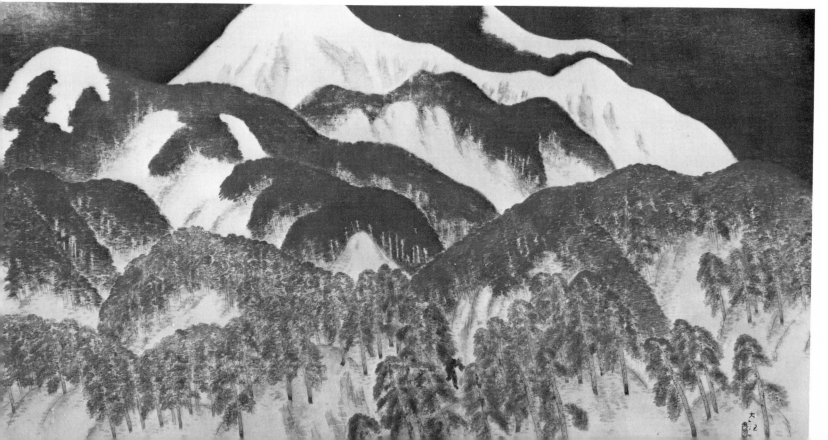

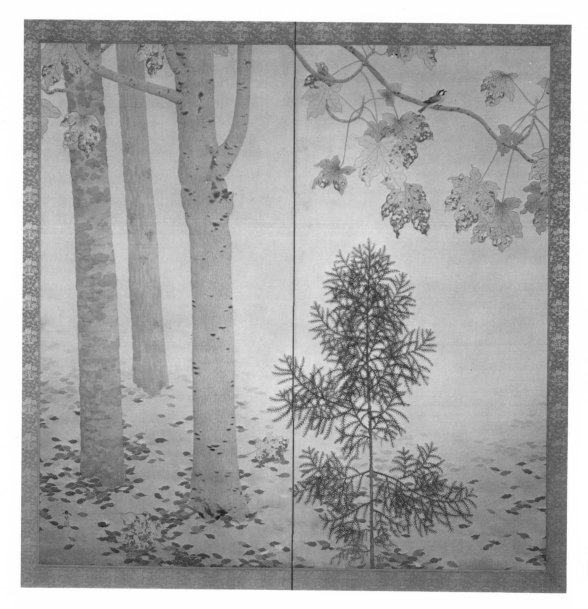

7
Hishida Shunso
Fallen Leaves. Meiji Period.

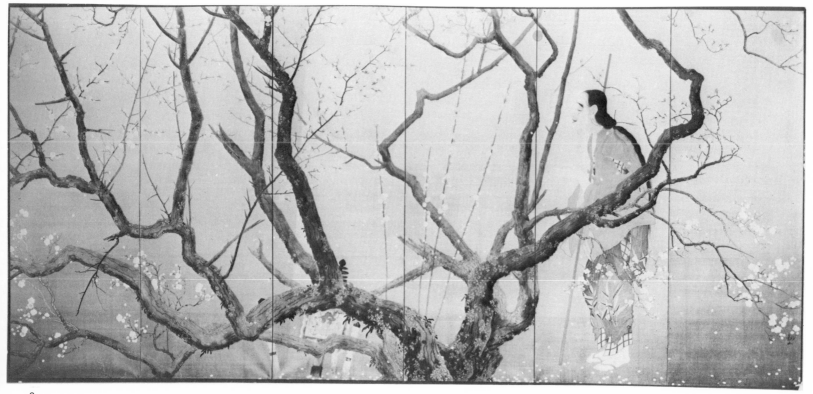

8
Shimomura Kanzan
Yorc boshi Screens. Meiji Period.

Kobayashi Kokei (1883–1958), and Maeda Seison (b. 1885) belong to another generation of Nihonga artists. The former was a native of Niigata while the latter came from a small town in Gifu prefecture, but both went to Tokyo at the turn of the century and have been associated with its art scene ever since. In contrast to the artists discussed before, all of whom were trained in the Kano tradition, these two were students of the Yamato-e painter Kajita Hanko, who emphasized the native Japanese style of narrative painting of the Heian period dealing with subjects from Japanese literature and history.

In keeping with his training, Kokei usually painted Buddhist themes or traditional Japanese subjects,

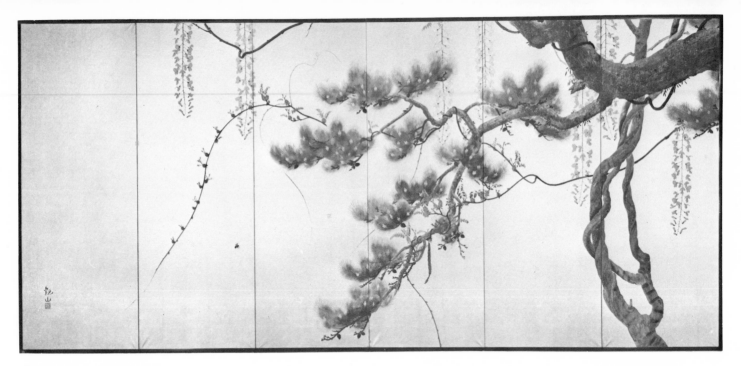

9
Shimomura Kanzan
Pair of screens with pine trees and wisteria. Meiji Period.

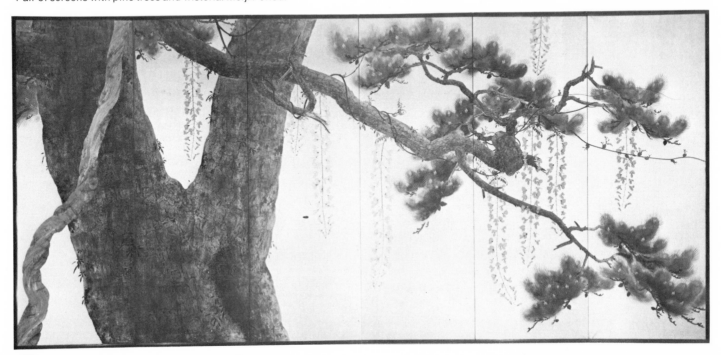

10
Shimomura Kanzan
Pair of screens with pine trees and wisteria. Meiji Period.

11
Kobayashi Kokei
The Tale of Kiyohime. Showa Period.

like the well known tale of the Bamboo Cutter, or Taketori Manogatari (plate 11). Other paintings represent scenes from contemporary life such as a young woman combing the hair of another, or two girls enjoying a hot bath, works in which the narrative traditions of Yamato-e and Ukiyo-e are combined with a certain realism, no doubt reflecting, in part, a Western influence. Kokei's most characteristic painting, and the one most critics regard as his masterpiece, is his version of the story of the Dojoji bell, a colorful narrative scroll painted in 1930.

Maeda Seison is a far more versatile artist than Kokei and has worked in a variety of styles. His most typical early work consisted of meticulously executed historical figure painting, the best known of which is "Yoritomo in a Cave." In his later work, however, he used a freer, bolder manner with a very expressive line. Typical of this style is his "Ashura" of 1940 and his sensitive portrait drawings. Very different again is his screen of 1953, "Red and White Plum Blossoms," executed in a decorative style similar to that of the

Rimpa school and recalling Korin's celebrated masterpiece on the same theme. Seison is equally at home in Chinese-style painting which he handles with a skill and subtlety rarely equalled and never surpassed in contemporary Japanese-style painting. His most outstanding work in this manner is a series of landscapes entitled "Eight Views of Kyoto," in the collection of the Tokyo National Museum (plates 12, 13). In these scrolls, a modern Japanese version of the famous Chinese series of the Eight Views of the Hsiao and Hsiang Rivers, Seison successfully combines elements of Chinese, Japanese and Western art, producing one of the masterpieces of contemporary Japanese-style painting.

The Ukiyo-e tradition of genre painting, based on the life of the common people of Tokyo, is best exemplified by still another contemporary painter, Kaburagi Kiyokata (1878–1972). A native of Tokyo, Kiyokata studied under Tsukioka Yoshitoshi and his assistant Mizuno Toshikata, well-known Bijinga painters of the Ukiyo-e school. The Bijinga painters specialized in paintings of beautiful young women. The most famous practitioner of the school was the eighteenth-century printmaker Utamaro. Kiyokata, like the Ukiyo-e artists whose traditions he continued, made his living by illustrating books, newspapers, and magazines. As a mature artist, however, he was widely recognized as the greatest genre painter of his period and inspired many followers among younger Nihonga painters. Filled with deep nostalgia for the time of his youth, he painted many pictures of female beauties of the Meiji period, the most famous of which is his celebrated "Tsukiji Akashicho" of 1927 (plate 14). He is

12
Maeda Seison
Views of Kyoto. Showa Period.

13
Maeda Seison
Views of Kyoto. Showa Period.

also much admired as a portraitist whose pictures of leading personalities of his day combine realism with decorative stylization.

The work of Kiyokata's contemporary, Kawai Gyokudo (1873–1957), is very different in style and subject matter. A native of Aiichi prefecture, Gyokudo started his artistic career in Kyoto but soon moved to Tokyo where he studied with Hashimoto Gaho who admired the young artist's work. Trained in the Shijo and Kano schools and exposed to Western art, Gyokudo tried to fuse these various styles into a new form of artistic expression. He was primarily an ink painter who employed subdued colors for tonal effects as if they were ink washes, instead of using them in a flat decorative manner. He combined Japanese technique and subject matter with European use of space in depth, light and shade which often gave his paintings a Western appearance. Most of his works are landscapes rendered in a lyrical, pastoral mood recalling English watercolors as much as Chinese landscapes of the Kano masters (plate 15). His "Colored Rain" of 1940 is a good example, with its peasant house, water mill, and rustic landscape.

14
Kaburagi Kiyokata
Tsukiji Akashicho. Taisho Period.

15
Kawai Gyokudo
Landscape After a Shower.
Showa Period.

16
Takeuchi Seiho
Landscape. Showa Period.

Next to Tokyo, the most important art center of modern Japan is Kyoto. The dominant artistic school in Kyoto during the Edo period was the realistic Shijo Maruyama school which continued to be very influential during the Meiji and Taisho periods. Its most celebrated practitioner was Takeuchi Seiho (1864–1942), who enjoyed extraordinary fame during his lifetime and is regarded by many critics as one of the masters of modern Japanese-style painting. A student of the well known Shijo school painter Kono Barei, Seiho received very conventional training but in 1900 was sent to Europe for six months to study Western art. Although he had little interest in contemporary Western painting, he was attracted to the Romantic masters, especially Turner and Corot, an admiration which is clearly reflected in his own landscape paintings of this period (plates 16, 17). His most characteristic work, however, was executed in a meticulously realistic style representing a modern version of the type of painting for which Maruyama Okyo had been famous. Among Seiho's best paintings are his portrayal of a maiko performing a Japanese fan dance which is entitled "Oh the Rain . . . ," and his paintings of various animals and fish. After a trip to China late in life, he began working in a softer ink style based on Chinese painting of the late Sung period, but it was in his pictorial compositions combining realism with decorative elements that he achieved his finest and most typical work.

17
Takeuchi Seiho
Landscape. Showa Period

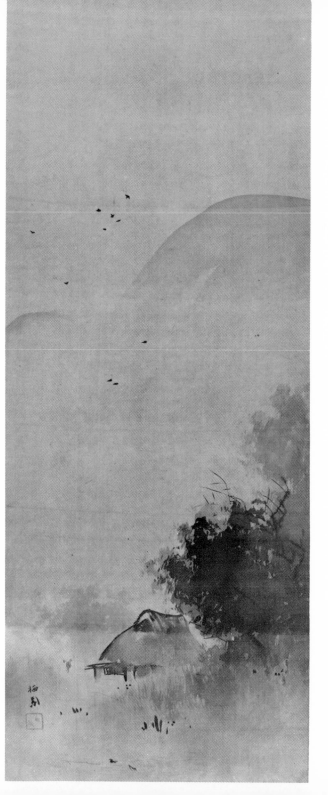

18
Uemura Shoen
Waiting for the Moon. Showa Period.

Another famous Kyoto painter who studied with Kono Barei, and after his death with Takeuchi Seiho, was the woman artist Uemura Shoen (1875–1949). She was most interested in painting female beauties and mothers and children in the tradition of the Ukiyo-e masters. Although neither very original nor profound, her work is always pleasing and it earned many prizes and enjoyed great popularity. Titles of her pictures such as "Mother and Baby," "Firefly," and "Spring and Autumn" suggest the type of subjects she was fond of painting (plate 18). Shoen used line and color very skillfully and her portrayal of traditional Japan was always done with taste and sensitivity. Many younger Nihonga painters have tried to emulate her, but none have proved her equal.

The second generation of Kyoto Nihonga painters is well represented by Fukuda Heihachiro (1892–1974). In contrast to Seiho and Shoen, who belonged to the Meiji period and were firmly grounded in the older tradition, Heihachiro has a much more modern outlook, with a keener awareness of the currents of the twentieth century. Although a native of Oita in Kyushu, he has been associated with the Kyoto art world ever since his arrival there as a student. While his themes and techniques are very traditional, Heihachiro reflects the influence of modern abstract art, as is most apparent in his famous "Rain" of 1953 which shows a typically Japanese tile roof in the rain and is now in the collection of the Tokyo Museum of Modern Art.

19
Kawabata Ryushi
Music of Spring Trees. Showa Period.

The maverick among the older generation of modern Japanese–style painters was Kawabata Ryushi (1885–1966). A native of Wakayama, Ryushi started his career in the Western style, but in 1912, during a trip to the United States, he was so impressed by the Japanese paintings at the Boston Museum of Fine Arts that he decided to take up the Japanese style. An independent who belonged to none of the art societies or schools, in 1928 Ryushi founded his own art organization, the Seiryusha, a group which is still active and contains some of the most gifted of younger Japanese-style artists. A dynamic painter who produced a large body of work, some of it huge in scale, Ryushi was a very influential figure in the art world of the Showa period, and he has greatly influenced the next generation of Japanese-style artists. Although employing traditional media and often using the screen format, Ryushi applied pigments as freely as if they were oils, achieving striking effects which are the very antithesis of the rather bland decorative style so typical of most of the contemporary Nihonga painters. Characteristic of his best work is his celebrated "Music of the Spring Trees" of 1932, now in the Ryushi Memorial Gallery in Tokyo (plate 19). A pair of large six-fold screens, it combines very successfully the native Japanese tradition of decorative screen painting with the modern emphasis upon abstract design.

49

20
Ogawa Gaboku
Abstract calligraphy. Showa Period.

The tendency to merge the two traditions often makes it difficult to decide if a given painting belongs to the Nihonga or the Yoga school. This trend is even more pronounced in the work of Ryushi's followers who, as members of a younger generation, are not only less familiar with the traditional culture but have also been far more exposed to Western influences. In fact, as the years go by, the borderline between Nihonga and Yoga is becoming less and less clearly defined because even the most dedicated Japanese–style painters cannot help but be deeply influenced by the Western currents which are transforming Japanese life, and the Yoga artists in turn are affected by contemporary interest in traditional Oriental art. The present situation is summed up very well by the art critic, Nakamura Tanio, who says, "Contemporary Japanese-style paintings are mostly in Western framed-painting format, rather than in that of the hanging scroll. The pictures have become larger and larger, the color denser and brighter. Thus Japanese-style paintings are approaching Western-style oil paintings, except for the difference in pigment. Though basically the classification of Japanese style and Western style has become artificial, there remains the tangible essence and spirit of a Japanese artistic sense which has produced the masterpieces of the past and lives today in its most vital form in the Japanese-style paintings of modern Japan."[14]

21
Ogawa Gaboku
Abstract calligraphy. Showa Period.

The meeting of East and West is perhaps best revealed in the school of avant-garde calligraphy called Zenei Shodo, which stands halfway between traditional Japanese writing and the abstract paintings of such modern artists as Klee, Miro, Tobey and Kline. Based on an ancient tradition which played an important role in the art of the Far East, this modern calligraphy is often so abstract that it can no longer be read. It conveys its message not through the meaning of the characters or their literary association, but through the beauty of their forms and the expressive power of the brush strokes on the paper. In this way it bridges the gap between the two artistic traditions, combining the techniques and conventions of traditional calligraphy with the spirit of modern abstract art, as in the work of Ogawa Gaboku (born 1911), one of the Zenei Shodo's outstanding artists (plates 20, 21).

Chapter 4
Japanese Western Style Painting

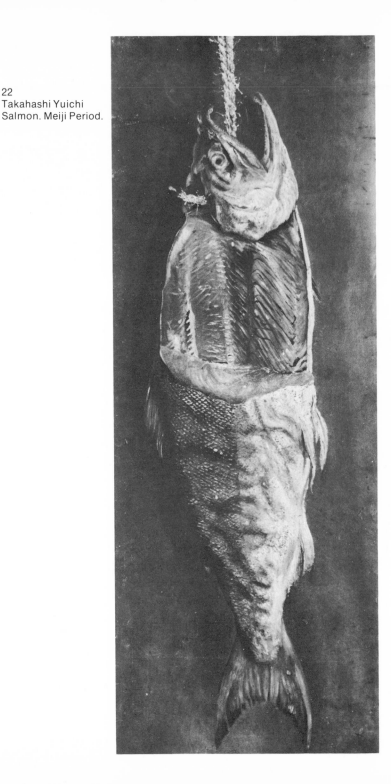

22
Takahashi Yuichi
Salmon. Meiji Period.

Although Western influences first reached Japan during the sixteenth century with the arrival of Portuguese and Spanish missionaries, and later during the eighteenth and early nineteenth centuries when illustrated books and prints were brought to Nagasaki by Dutch traders, it was not until the Meiji period that Western art became widely known. The founder of Western–style painting in Japan was Kawakami Togai (1828–1881). As a young man he worked in the Bunjinga style, but after studying Dutch he became interested in European art and began to learn the conventions and techniques of Western painting. His instructor was Charles Wirgman, the English journalist and painter who was the first foreigner to teach Western art to the Japanese. In 1857 Kawakami was appointed Inspector of Painting in the Bureau for the Inspection of Foreign Documents, and later to the Kaisei School. There a Painting Office was set up in 1861 in which the artist was able to instruct several young students in the new techniques. In 1871 he published a book called *A Guide to Western Style Painting* which had a considerable influence. Kawa-

kami was not outstanding as an artist, but he played a vital role in introducing European art to the Japanese.

Far more significant as a painter was his pupil, Takahashi Yuichi (1828–1894), whose work even today is impressive for its realism. Strangely enough, the first Western–style art Takahashi saw was a signboard painting made by a Japanese artist to advertise an optician's shop. Struck by its realism, he began to imitate the Western models he could find; initially a few lithographs and colored reproductions, until some Japanese students brought back oil paintings from Holland. Under the tutelage of Wirgman and Kawakami, Takahashi became an accomplished Western–style painter who enjoyed great success. He was also the founder of a private art school called Tenkaigakusha and later he became a professor at the Tokyo Imperial University. By the 1870's, as his work and that of his pupils began to attract attention, his leadership in the field of Yoga was clearly established. In 1880 he founded an art magazine, the first of its kind in Japan. Among his numerous works the most famous is his picture of a salmon suspended from a string, painted in 1877 and now in the collection of the Tokyo University of the Arts, the former Tokyo School of Fine Arts (plate 22). Done in oil on canvas in a very realistic manner, it shows how, within ten years of the Meiji Restoration, Japanese painters had completely mastered European styles and techniques.

Among the Yoga painters of the next generation, the first important figure was Asai Chu (1856–1907). Born almost thirty years after Kawakami and Takahashi, he grew up during the early Meiji period when the craze for everything Western had reached its height. He studied with the Italian painter Antonio Fontanesi at the Tokyo School of Fine Arts where he in turn became a professor in 1898. Unlike the earlier Western-style painters who had never been abroad, and whose knowledge of European art was largely confined to second–rate examples and reproductions, Asai was sent to Europe in 1900 so that he could have a chance to see for himself some of the masterpieces of Western art. His work clearly reflects the current European developments, notably Impressionism, which at that time was still at its height.

Asai was very active in Tokyo art life, and he played a leading role in the Meiji Art Society which had been founded in 1889 to further the knowledge of Western art and to exhibit Japanese work painted in the foreign style. His early works, such as "Bridge at Grez", were first shown at exhibitions given by this society. Their dark tonalities with browns and somber green predominating are characteristic of his early style, which reflects the influence of Courbet and the Barbizon school. After his return from his two–year stay in Europe, however, his palette became lighter and his brushwork more impressionistic, reflecting the manner of artists like Monet and Pissarro.

The culminating figure in the Western-style painting of the Meiji period was Kuroda Seiki (1866–1924). Born two years before the Meiji Restoration, he was almost an exact contemporary of Yokoyama Taikan and he had much the same position in the development of Yoga as Taikan did in Nihonga. A native of Satsuma, Kuroda came from an old samurai family. In 1884 he went to Europe to study law, but while there decided to become a painter. He chose as his teacher Raphael Colin, a minor French artist who combined the contemporary Impressionist idiom with a firm academic foundation. During his ten years in Europe, Kuroda developed a deeper understanding of Western art than any other Japanese before him, and he created works which were not just imitations of foreign models but independent, creative achievements in a Western style.

Returning to Japan in 1893, Kuroda at once emerged as the leader of the Western–style painters, a position which probably owed as much to his forceful personality and social status as to the excellence of his work.

He founded an art school called Tenshin-dojo in 1896 and became a leading member of the Meiji Art Society, which in 1894 exhibited his "Morning Toilette", showing a nude woman he had painted in France using a French model. Since the public was not accustomed to nudes, it caused a sensation and the government asked that it be withdrawn, a request which was not complied with. In 1896 Kuroda split with the society and founded his own group, called Hakuba-kai, which favored a more modern Impressionist style rather than the conservative realism espoused by the members of the Meiji Art Society.

Kuroda's later career led from triumph to triumph, and by the late Meiji period he had emerged as the dominating figure in Western–oriented art in Tokyo. In 1896 he became professor at the Tokyo School of Fine Arts where he taught many of the most prominent young painters of the period. He also became a member of the Imperial Art Committee and president of the Imperial Art Academy. The rich acclaim he achieved was not restricted to Japan; when he exhibited his work at the Paris World Exposition of 1900, he received a silver medal.

Among his many works, the most important are his numerous depictions of women, who are shown in a variety of poses and engaged in various activities. In his choice of subject matter, it might be said that he is a Western–style equivalent of the traditional Bijinga painters. His best known work of this type is "Lakeside" painted at Hakone lake in the summer of 1897 and now owned by the National Cultural Property Research Institute (plate 23). Although it shows a Japanese girl dressed in a kimono and holding a fan, both its style and conception are clearly derived from European prototypes.

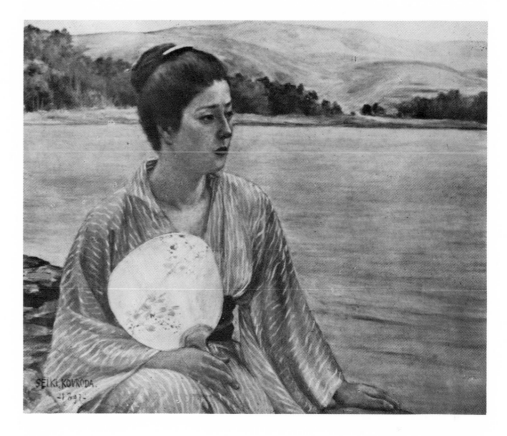

23
Kuroda Seiki
Lakeside. Meiji Period.

Somewhat younger than Kuroda and outliving him by many years was Fujishima Takeshi (1867–1943), once his pupil and later his colleague at the Tokyo School of Fine Arts. Starting his career as a student of Japanese-style painting under a master of the Shijo school, Fujishima switched to the Western manner in 1891 when he was twenty-four years old. After teaching in a public school in Ise, he was appointed to the faculty of the Tokyo School of Fine Arts in 1896 where he had an important influence both as teacher and painter. In 1905 he went to Europe, where he remained for two years. In Paris, he was profoundly influenced by the Impressionist painters and produced some of his best work under their inspiration. After his return to Japan, however, he developed a more decorative manner, closer to the Japanese tradition, which resulted in a more personal kind of expression in which modern Western and Eastern elements were combined. He excelled both in landscapes and in portraits of women, a good example of which is his "Hokei" of 1926. Particularly fine are the landscapes of his maturity, like "Sunrise in the Eastern Sea" of 1920 in which the forms are simplified and stylized, emphasizing the decorative effect of the color patterns instead of trying to catch a momentary impression of the scene. Continuing to work throughout the thirties, Fujishima emerged as the most outstanding and influential Western-style painter of the Taisho and early Showa period.

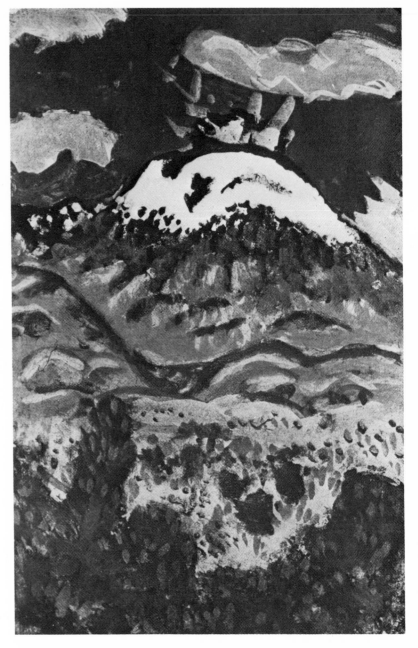

24
Umehara Ryuzaburo
Mountain Landscape. Showa Period.

While Kuroda and Fujishima were the two leading Western-style painters of the generation which became dominant during the late Meiji and Taisho periods, the outstanding oil painters of the next generation were Umehara Ryuzaburo (b. 1888) and Yasui Sotaro (1888–1955). Both men were born in Kyoto in the same year, but while Yasui died at sixty–seven in 1955, Umehara is still alive and active at the time of this writing. While Impressionism had been the major trend in Paris when Kuroda and Fujishima lived in France, the most important influence on these younger artists was the Post-Impressionist movement.

A native of Kyoto, Umehara studied at the Kansai Bijutsuin Art School under Asai Chu, who had moved from Tokyo to Kyoto after his return from Europe. In 1908 Umehara went to Paris, where he studied with Renoir. However, a much stronger influence was the work of Cézanne, Van Gogh and especially Gauguin, whose more abstract style, influenced by Japanese prints, proved more congenial to the young artist. Returning to Japan in 1913 at the age of twenty–five, Umehara exhibited a series of nudes in the manner of the late Renoir. His true genius, however, manifested itself later, in a bold, expressive style with thickly applied brilliant palette. His landscapes recall those of the German Expressionists in the intensity of their emotion, and his nudes and still lifes have a forceful, original style with strong linear accents and flat, bright colors. (plate 24). No Japanese artist had ever used oils in such a vigorous, expressive manner.

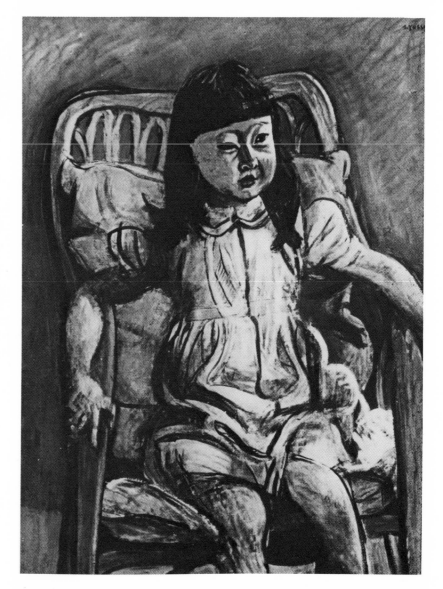

25
Yasui Sotaro
Grand-daughter. Showa Period.

59

Yasui Sotaro also studied with Asai in Kyoto and then spent eight years in Paris where at first he was influenced by Pissarro, though it was Cézanne who had the most important effect on his development. This is especially apparent in the still lifes and landscapes he painted between 1910 and 1913. His later work reflects Matisse with its rhythmic lines and flat, decorative color. In contrast to Umehara's expressionism, Yasui is a decorative artist, closer to the School of Paris. His subjects are usually landscapes, nudes and still lifes, but among his best and most original works are his portraits which combine good characterization of the sitter with a subtle use of line and subdued color (plates 25, 26).

While Umehara and Yasui never really went beyond the ideals and conventions of Post-Impressionism, other artists moved in new directions corresponding to the avant-garde trends of twentieth century French painting. The most remarkable was Yorozu Tetsugoro (1885–1927) whose artistic career corresponds almost exactly to the Taisho period. Yorozu made his debut with his "Nude Beauty" of 1912, his graduation work at the Tokyo School of Fine Arts, which is recognized today as the first Fauvist painting in Japan, painted only seven years after the movement began in Paris. After this he joined a group of experimental artists called La Société du Fusain, which challenged all the assumptions of the older Western-style painters. His second phase, during which he left Tokyo for his home town in the farming district of Iwate prefecture, culminated in the "Leaning Woman" of 1917, the first Cubist picture painted in Japan. Since Yorozu had never been to Paris but derived his knowledge of avant-garde French painting from magazines, this accomplishment is really quite amazing. Strangely enough, after the revolutionary work of his earlier years, Yorozu at the age of thirty-two took up Japanese-style painting of the Bunjinga type and made woodcuts, none of which compare with the originality and creative power of his Western-style work.[15]

However, Yorozu was not the only young painter experimenting with new styles. Fauvism, Cubism, Expressionism and Surrealism all had their followers in Tokyo, and as soon as a new movement originated in Paris, it was taken up in Japan. It is difficult to choose among the many painters active during this period. Of the Taisho artists working in an expressionistic style, the most gifted was Saeki Yuzo (1898–1928) who spent most of his adult life in Paris where he was greatly influenced by Vlaminck. His poetic interpretations of the streets of Paris are marked by a sensitive and melancholy beauty. Unfortunately his career was ended by his death at thirty in 1928. Although Surrealism was already known in Japan in the late twenties, it never had a really strong influence. The only outstanding painter of this period who might be considered a Surrealist was Koga Harue (1895–1933). His imaginative depiction of seemingly unrelated figures, objects and landscapes, executed in a meticulously realistic style, recalls the work of De Chirico, and is not unlike the American painter Peter Blume. At his best, the result is strangely evocative, the dreamlike images no doubt giving expression to the unconscious of the artist. Another outstanding figure was Kishida Ryusei (1881–1929) who, as a young man, was one of the founders of the avant-garde Fusain group. After starting out in an experimental style, he became very interested in the work of Albrecht Dürer, and between 1918 and 1924 painted a number of portraits of his daughter Reiko in a realistic style based on the work of the German Renaissance

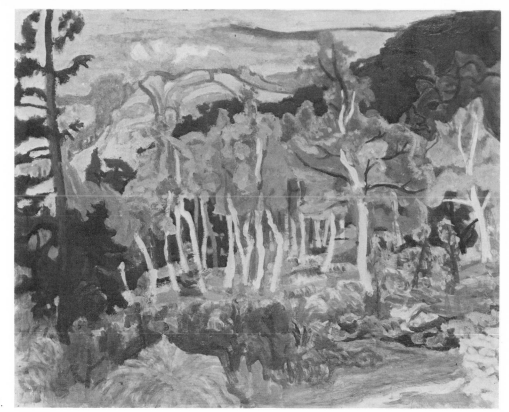

26
Yasui Sotaro
Landscape. Showa Period.

master. Yet his subject matter and his subdued palette seem quite Japanese, and it is interesting that like Yorozu, Kishida took up Japanese–style painting in his later years, although his best work was without question his earlier oil painting.

The 1930's was a stagnant period for Western-style painting. As Japan grew more militaristic, with extreme nationalism on the rise, the government and to a certain extent the public became hostile to modern art and the period of bold experimentation came to an end. The well-known avant-garde painter Yoshiwara Jiro, who was a young man at the time, calls this era, "the darkest period of my life, for I tasted how bitter and miserable it is to live under a totalitarian society."[16] Having discovered Kandinsky, Yoshiwara was experimenting with abstraction, but as he says, "It was quite natural that my work, which was regarded as radical and un-Japanese, was often attacked. Japan was entering the mad era of militarism, and I was accused of spending time idly painting circles and triangles during a period of national emergency." In the war years many painters were either commissioned as war artists or drafted into the army and this, combined with the hardships and deprivations of the home front, all but paralyzed the artistic activity of the forties.

Yet even during this period Japan could not completely isolate herself from the outside world, and foreign art books and magazines continued to arrive and young Japanese still went abroad for study. Modern art shows were held in Japan, like the large exhibition of contemporary French painting shown in Tokyo in 1932. In 1937 an exhibition called ''Surrealism Overseas'' was staged in Tokyo which included the work of French and English fantastic and surrealistic painters that created quite a sensation among the young artists. Breton's *Le Surrealisme et La Peinture* had been translated into Japanese in 1930, and Japanese art critics were quick to report the new developments in Europe.

Although Western–style painters received little encouragement from official sources, this was a formative time for many of the artists who were born around 1900 and emerged as the leading Japanese painters of the post-war period. Some found their way to Paris but others had to work out their own style by experimentation and through association with other artists who were also groping for new forms. Men like Hayashi Takeshi (b. 1896) who worked in a Fauvist manner, Fukuzawa Ichiro (b. 1898) who was using a Surrealist idiom, and Yoshiwara Jiro (b. 1905), who was experimenting with abstract forms, were already emerging as figures of consequence. However, the most significant contributions during these years were probably made by men of the older generation, notably Umehara and Yasui who did some of their best work during this period.

The outlook for a revival of the cultural and artistic life of Japan seemed very bleak after the surrender of 1945. The country lay in ruins, but the submerged creative forces had continued to evolve; for in a very short time Japan experienced a rebirth of unprecedented proportions. Modern art, which had suffered the brunt of the attack during the years of totalitarianism and war, made a spectacular recovery. The occupation of Japan by Western powers resulted in an exposure to foreign influences which had no parallel in Japanese history. Exhibitions from Paris and New York were shown in Tokyo and other urban centers, and Japanese publishers brought out innumerable books and magazines dealing with modern art. The result was a period of great artistic flowering.

For the most part, the artists who came into prominence during the fifties and sixties were those who had been born at the very end of the Meiji period and had grown up during the twenties and thirties. Although there were painters representing many movements from realism to non-representational painting, and innumerable artist groups from the traditional to the widly experimental, the dominant trend, especially during the last decade, was toward greater and greater abstraction. Terms like Abstract Expressionism, Tachism, L'Art Informal and Art Concrete, derived from French and American painting of the period, were freely applied to the work of Japanese artists who professed similar ideas and goals. Exhibitions of post-war French painting and works by Jackson Pollock and the School of New York painters had a tremendous impact on Japanese artists and their work in turn won international prizes in Venice, New York and São Paulo.

The outstanding figure in the post-war abstract movement is Saito Yoshishige, who was born in Tokyo in 1904. One of the pioneers of abstract painting in Ja-

27
Saito Yoshishige
Abstraction. Showa Period.

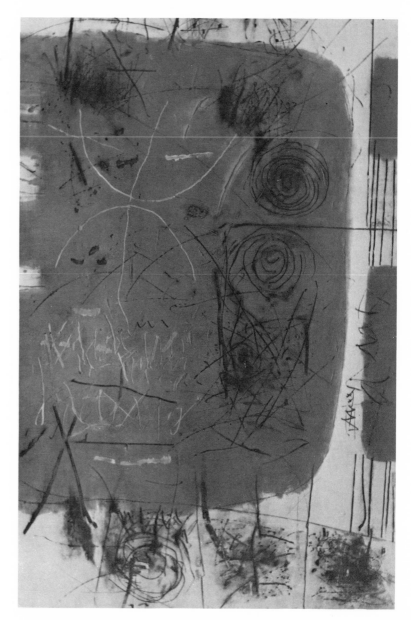

pan, Saito had already worked in this style in the thirties and in 1939 was one of the founders of the Modern Art Association. A painter of great sensitivity and subtlety, Saito brings to abstract painting a sensibility which is typically Japanese. He first came into prominence in 1956 with a series of pictures which represent a kind of demon called oni and combine ancient Japanese conceptions with modern art. However, his international fame is based on his nonobjective works of the late fifties and sixties. Usually executed on plywood, they have graffiti-like designs scribbled over colored surfaces. The effect is often very beautiful, especially in his use of a quick spontaneous line (plate 27).

Two other leading abstractionists are Yamaguchi Takeo and Murai Masanari. Yamaguchi who was born in Seoul, Korea in 1902, first studied at the Tokyo School of Fine Arts and then in Paris under Saeki and Zadkine from 1927 to 1930. The most important influence on his development was Leger, whose bold, simple forms are clearly reflected in Yamaguchi's painting. In his mature work, the artist combines this style with traditional calligraphic forms, creating large rigid flat images resembling simplified Japanese characters executed in light colors against a darker ground. Like Saito, he prefers using plywood board to canvas and applies layers of mustard yellow and black paint with a palette knife. The result is a strong, simple art which has an enduring, monumental quality, very different from the subtle linear work of Saito.

Although belonging to the same generation and also working in the abstract idiom, Murai Masenari is different again. Born in Gifu prefecture in 1905, he studied in Paris from 1928 to 1933 and was a founder of the modern art group called the New Age Show. Already working in the non-objective manner in the 1930's, his paintings of that time clearly reflect the influence of Mondrian and Neo-Plasticism. His work of the post-war period, however, is closer to Leger and the late style of Klee. Using heavy black linear forms against a lighter colored ground, he achieves strong contrasts between different shapes and color patterns, combining the lessons of cubism and constructivism with traditional Japanese calligraphy. Although the shapes are abstract and exist in a realm of pure form, they often suggest all kinds of associations and images from nature. The titles he gives his compositions indicate that these allusions are intentional and are meant to suggest the natural images underlying the seemingly pure abstract forms.

Better known to the international art world are two Japanese abstract painters living abroad, namely Okada Kenzo and Sugai Kumi. Okada, who has lived in New York since 1950, was born in Kanagawa prefecture in 1902 and is a contemporary of men like Saito, Yamaguchi and Murai. Educated at the Tokyo School of Fine Arts and in Paris, his early training was also very similar to theirs. As a member of the Nika-kai, the most famous avant-garde artists' group in Japan, he had already worked in an abstract idiom before the war. However, his great international success dates from the 1950's after he had settled in the United States. Contact with the vital and lively New York art world, especially the work of the late Mark Rothko, stimulated Okada's creativity and resulted in a new style which combines a typically Japanese sensibility with modern abstraction. Although today Okada is often referred to as an American painter since he has lived in the United States for over twenty years and has produced much of his best work in America, he is essentially Japanese. His subdued tonalities and feeling for quietness are far closer to the spirit of Zen than to the explosive expressionism of the New York Action painters (plate 28).

Sugai Kumi was born in Kobe in 1919 and therefore belongs to a somewhat later generation. A product of the post-war period, he settled in Paris in 1952 and came into prominence in Europe and New York long before he was recognized in his own country. In spite of his years abroad, or perhaps because of his encounter with a foreign culture, Sugai's work is very Japanese in feeling, and in his own life he has deliberately maintained his identity as a Japanese. His abstract forms are clearly derived from ancient calligraphy as well as from traditional Japanese images like the stone gardens of the Zen temples and figures from Japanese legend. Despite the modern abstract idiom in which he works, his painting has a subtle, poetic beauty reminiscent of older Japanese art. But then, the two have much in common, and Sugai succeeds in fusing the traditions, thus creating a highly personal form of expression (plate 29).

In addition to the artists working in the abstract idiom, there were innumerable others whose paintings reflected more traditional styles. In fact, the entire range of modern art could be found in the exhibitions of post-war Japan. Among older painters Realism, Im-

28
Okada Kenzo
Posterity.

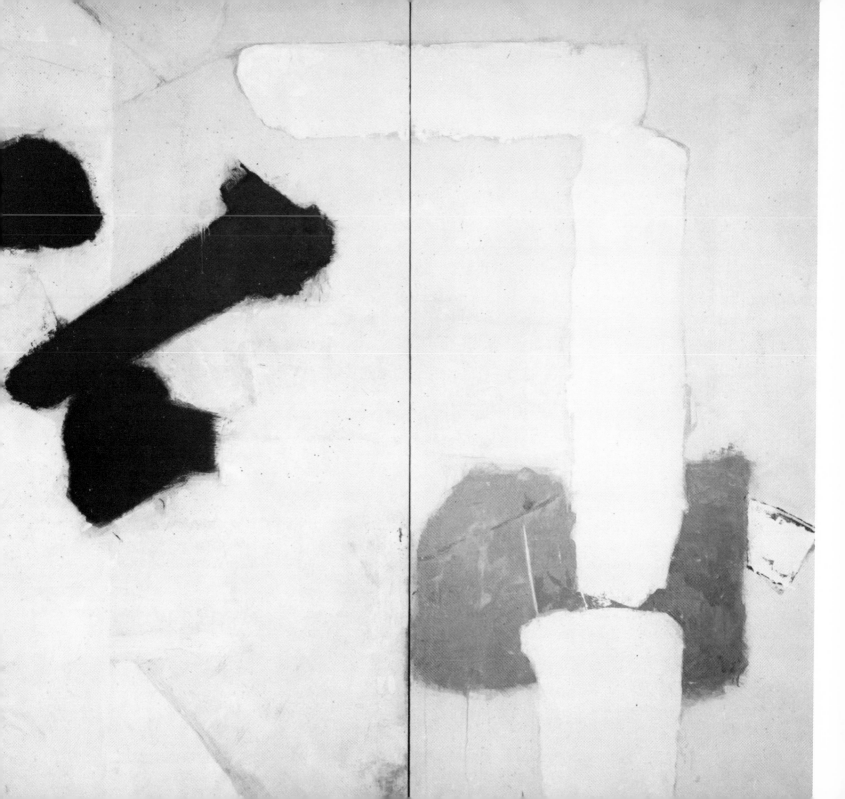

Nagai Kumi
Autoroute au Soleil. Showa Period.

30
Migishi Setsuko
Goldfish. Showa Period.

pressionism and Post-Impressionism still had their followers, as did all the twentieth century movements such as Fauvism, Cubism, Expressionism, Surrealism and Social Realism. The towering figure among the many gifted artists was Umehara, who in his old age was still vigorous and productive, and had clearly emerged as the grand old man of Western-style painting, just as Seison had among the painters working in the Japanese style. Tokyo, with some 25,000 artists, had become one of the great art capitals of the world, rivalled only by New York and Paris.

The most talented artist working in the Fauve style would no doubt be Hayashi Takeshi (1896–1975), one of the pioneers of modern art in Japan and professor at the Tokyo School of Fine Arts, rechristened Tokyo University of Arts. His mature work, especially his fe-

male portraits and still lifes, is imbued with artistic taste and vitality.

Among those using the Expressionist style, Tanaka Tatsuo (b. 1903) is outstanding for his moving depictions of Christian subjects in a bold, dramatic style which resembles the paintings of Rouault (plate 31). The Cubist tradition is well exemplified by Migishi Setsuko (b. 1905), whose work is typically Japanese in its sensibility, with subdued colors and subtle tonal variations (plate 30). Although Surrealism never really caught on in Japan, Surrealist elements can be found in the highly imaginative and sometimes humorous paintings done by Katsura Yukiko (b. 1913) in the 1950's, though her later work tends toward a more abstract style, in which subtle collage effects are used with great sensitivity (plates 32, 33).

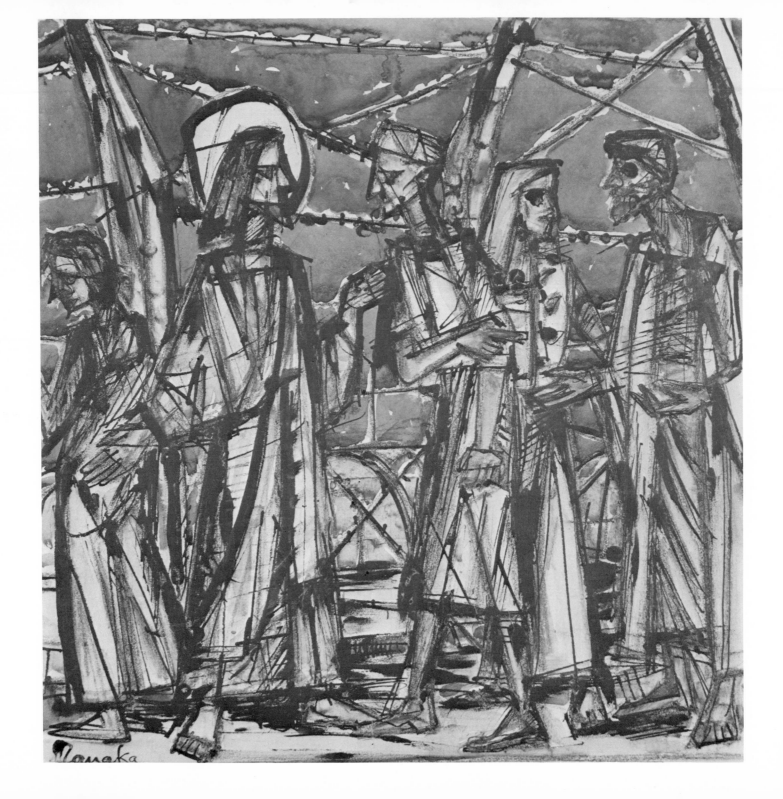

The 1960's saw the emergence of a new generation of artists, products of the post-war period. Their work first appeared in the many post-war shows sponsored by big newspapers, the many artists' groups and the museums of modern art which have sprung up in Tokyo, Kyoto, Kamakura and even such provincial towns as Nagaoka. The work of these artists has achieved acclaim not only in Japan but also abroad. The exhibition called The New Japanese Painting and Sculpture, held at the Museum of Modern Art in New York in 1966 and circulated throughout the United States, consisted primarily of the work of these younger artists, and the Japanese National Committee for the International Association of Plastic Arts has also sent exhibitions of contemporary Japanese art to New York, Paris, Mexico City and other art centers.

Here again, it is difficult to single out a particular figure or group from the many who have emerged during the decade. All of the trends which are found in New York and Paris have their equivalents in Japan, and some Japanese critics even claim that the very first "Happening" was staged in Osaka and only later imitated in New York. Be this as it may, all the recent movements—Pop, Op, various kinds of abstraction, Informal Art, Happenings, Neo-Dadaism and anti-art—have appeared in Japan. The latest developments of the New York and Paris art scenes are discussed and shown in Japanese art journals almost as soon as they occur, while a steady stream of Japanese artists makes the trip to New York, Paris, London and Rome.

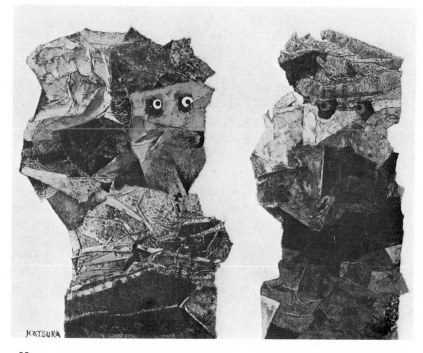

32
Katsura Yukiko
Red and White. Showa Period.

31
Tanaka Tatsuo
Christ Among Prisoners. Showa Period.

The most notorious artists' group is the one called Gutai, meaning concrete form, which was founded in Osaka in the early fifties by some twenty young artists who gathered around the veteran avant-garde painter Yoshiwara Jiro. As the art critic Tono Yoshiaki says in his discussion of post-war Japanese art, "They staged happenings, outdoors or on a stage, to demonstrate that art can spring from chaos and chance. They had not lost their sense of innocent fun. Atsuka Tanaka draped innumerable pieces of pink and yellow cloth in a pine forest near the sea and let them flutter in the wind like banners. Sadamasa Motonaga hung vinyl bags filled with liquids in many bright colors from a ceiling so that they shone like a cluster of giant drops suspended in mid-air. Kazuo Shiraga mixed clay with water, then jumped into it, leaving traces of his action in the mud. Saburo Murakami used large pieces of gold foil as a wall and hurled himself through it, leaving the jagged mark of a man's figure."[17] Of course, such antics do not last long, and produce little of enduring value, but they suggest the experimentation and vitality characteristic of present day Japanese art.

It is too early to decide which of these young artists are the leaders of their generation, but it can certainly be said that as a group they show both originality and creativity, and that they are taking their place along with their American and European contemporaries as the spokesmen for a new generation. Having grown up during the turmoil of the post-war years, they are no longer tied to the old traditions and it is safe to say that under their leadership, the art of Japan will become more and more a part of an international art scene in which the work produced in Tokyo and Osaka will hardly differ from that of New York, Paris or Bombay.

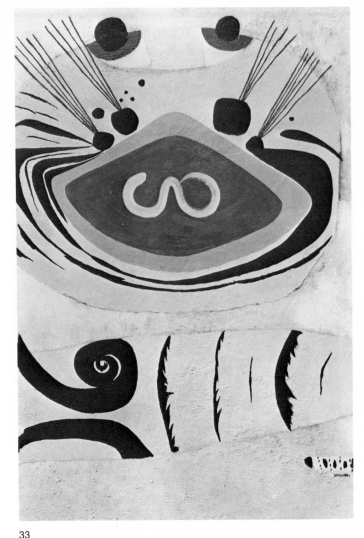

33
Katsura Yukiko
A Tiger. Showa Period.

Chapter 5
Modern
Japanese
Prints

With the death of Hiroshige in 1858, ten years before the Meiji Restoration, the great period of Ukiyo-e printmakers drew to a close. Many minor printmakers continued to produce woodcuts representing Kabuki actors, courtesans, and landscapes, but the quality of their work declined sharply in comparison to that of their predecessors. The designs were cluttered and poorly drawn, and the substitution of chemical pigments for the more subtle mineral and vegetable dyes of the earlier artists produced harsh and garish colors. Although the output continued to be large for at least another generation, by the end of the nineteenth century the traditional prints no longer played any important role. As Donald Keene says, "It is possible to date the end of Ukiyo-e with some precision: a report in the Yokohama Shimbun published in the autumn of 1895 noted the sales of nishiki-e had dropped drastically."

The most interesting prints of this period are those representing foreigners. Since Admiral Perry's arrival in Japan in 1853, woodblocks depicting Europeans had been very popular, because the Japanese were fascinated by their appearance and customs. The earliest of these prints were struck off clay blocks and called Perry Tile Prints, or Perry Kawara-ban. They were followed by Red Hair Prints, so called because North Europeans were said to have red hair, a trait which fascinated the Japanese. Another set known as the Civilization Prints showed such various aspects of Western culture as steamships, buildings and fashions. By far the finest, however, are the so-called Yokohama prints produced by a number of excellent artists, notably Hiroshige III (1843–94) and Sadahide (1807–73). Although lacking the refinement of the best of the old prints, particularly in terms of color, these prints are often pleasing as pictorial compositions and always fascinating as social documents. Produced for the most part during the early eighteen-sixties, they enjoyed a great popularity in their own time and have had a nostalgic revival in recent years. The entire life of this port city, which sprang up almost overnight, is portrayed in the Yokohama prints: the arrival of the foreign ships, the military parades, the elegant dress of the Western ladies and their strange domestic customs (plate 34).

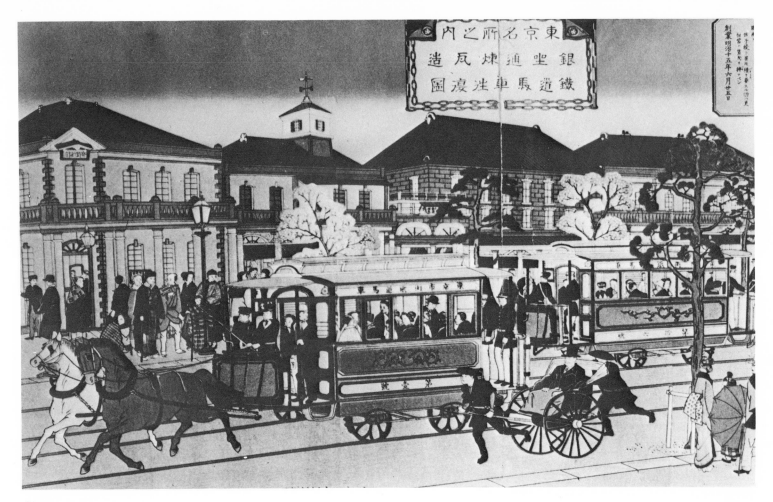

34
Hiroshige 3rd
Trolley on Ginza. Meiji Period.

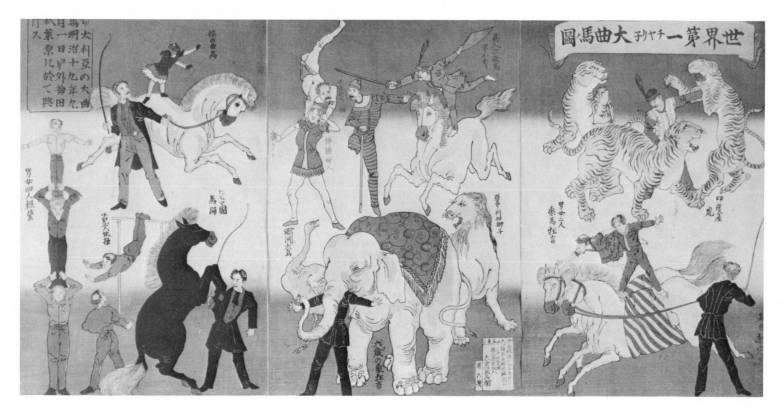

35
Attributed to Takanobu
Circus Scene. Meiji Period.

These prints continued to be made in Tokyo during the early Meiji period, although the subject shifted to the Japanese themselves, walking along the Ginza in Western clothes and taking the train at the newly-built Shimbashi station. Here again, from a purely aesthetic point of view, these prints leave much to be desired, but as a pictorial record of early Meiji Japan, they are invaluable. The opening of the first railroad line from Yokohama to Tokyo, the visit of ex-president Grant, the First Industrial Fair in Tokyo, or the promulgation of the constitution by the Meiji Emperor, were all recorded by contemporary print-makers. The most delightful are perhaps the prints of the European circus coming to town, with animated depictions of tigers, elephants, horses, acrobats, and clowns (plate 35), and the charming prints of Japanese ladies making Western-style gowns on their sewing machines, or playing the piano dressed in the latest Paris fashions, with ruffles, bustles, and bonnets.

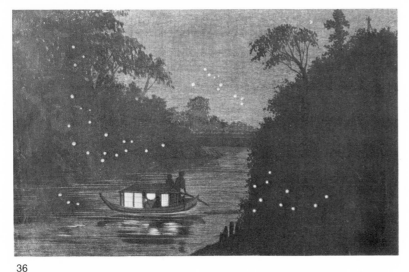

36
Kobayashi Kiyochika
Fireflies at Ochanomizu. Meiji Period.

The most original of the many woodcut artists who were active during the Meiji period was Kobayashi Kiyochika (1847–1915). The son of a minor government official, he was twenty-one years old at the time of the Meiji Restoration. Trained in Ukiyo-e as well as in traditional Japanese painting, he also studied Western-style painting and photography. His mature work embodied all these elements and proved very popular with the public. Above all, his Tokyo prints of the late seventies and early eighties gained considerable renown. In addition, he illustrated books, magazines and newspapers, and was the outstanding artist of the Sino-Japanese and Russo-Japanese conflicts. His total output was vast and although much of it is mediocre, at his best he was the pre-eminent printmaker of his period (plate 36).

37
Kobayashi Kiyochika
Omaru in Ofuba-town. Meiji Period.

In assessing Kiyochika's work, he has, at various times, been called the last of the great Ukiyo-e masters and the first of the modern woodcut artists. Actually, he is a transitional figure, combining elements of Western art with aspects derived from the native tradition. He employed the time-honored methods of wood engraving, but his use of shading and treatment of space clearly reveal his knowledge of chiaroscuro and perspective. His famous print showing the flow from a furnace in the iron works combines a portrait of modern industrial Japan with the use of light and shadow to create a feeling of atmosphere and plastic form. Other typical subjects are night scenes with dark figures silhouetted against a sky illuminated by fireworks and the newly-installed gaslights in the streets of Tokyo (plate 37).

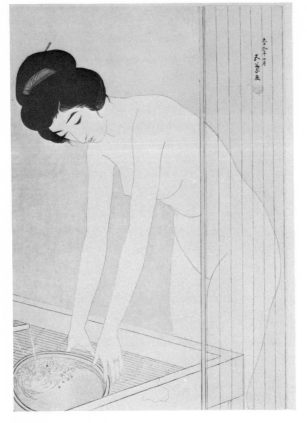

38
Hashiguchi Goyo
Bather. Taisho Period.

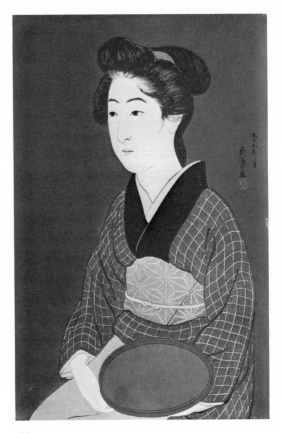

39
Hashiguchi Goyo
Onao-san of Matsuyoshi Inn. Taisho Period.

The group of printmakers coming into artistic maturity during the Taisho period (1912–26) produced the New Print, so-called in contrast to the traditional Ukiyo-e print on the one hand, and the modern Hanga print on the other. Although these men were obviously influenced by Western art, which most of them had studied, they used Japanese subject matter and employed professional wood engravers and printers to produce their work. Although some of the New Print Group continued to play a role during the postwar period, their most important contribution was made in the twenties and thirties during the Taisho and early Showa period. Among foreigners, especially, their picturesque prints of traditional Japan, combining typically Oriental themes with an artistic style derived from Western models, proved immensely popular, and have continued in great demand even to today.

The most outstanding of the New Print artists was without question Hashiguchi Goyo (1880–1921). A graduate of the Tokyo School of Fine Arts, where he specialized in Western-style painting, Goyo was very much a child of the new age. Yet, at the same time, like so many of these artists, he had also studied traditional Japanese-style painting and was a student of Ukiyo-e prints, about which he had written a book. His works are few in number, but surpassingly fine. A consummate draughtsman, Goyo made meticulous sketches in a very detailed, realistic manner, and produced pictures which in their perfection of design equal those of his idols Utamaro and Choki. His favorite subjects were elegant young beauties whom he portrayed either exquisitely dressed or partially, or wholly, disrobed. In these works, the aesthetic sensibility of the Japanese printmaker is evident, for they combine a sure sense of decorative design with a good use of line and color (plates 38, 39).

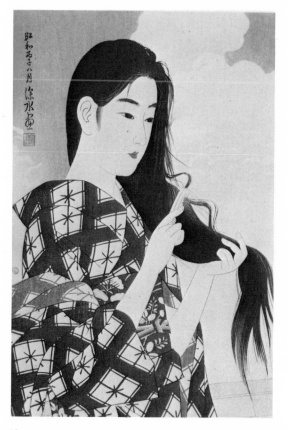

40
Ito Shinsui
Girl Combing Her Hair. Taisho Period.

41
Ito Shinsui
Lotus Flowers. Showa Period.

Ito Shinsui (1898–1972) was a somewhat younger artist who also specialized in the representation of beautiful women, or Bijinga. A student of Kaburagi Kiyokata, the artist was trained in Japanese-style painting, although he was also familiar, through his travels, with Western art. Today he is probably best known for his paintings of young girls; from 1916 on he also produced a number of fine woodblock prints (plates 40, 41). As with Goyo, Shinsui's art reveals the dual influences of Japanese and Western art, particularly in its greater emphasis on shading at the expense of line. Shinsui also made several sets of landscape prints, of which the most famous is that produced in 1917, devoted to "The Eight Views of Lake Biwa."

Takeshisa Yumeji (1884–1934) is currently having a revival as the most typical of the Taisho period printmakers. Born in Okayama, Yumeji came to Tokyo in 1901 and was trained in oil painting, watercolor, and printmaking. Much of his work consisted of book and magazine illustration, but today he is best remembered for his woodcuts. In contrast to Goyo and Shinsui, who based their work on Ukiyo-e, Yumeji was influenced by Gauguin and Art Nouveau. Unlike the traditional printmakers, he cut and printed his own blocks. His best works are close-up portraits and scenes from contemporary life, rendered in vivid colors and strangely elongated forms. His style is very original, with the striking contrast between the brightly-colored garments and the pale, melancholy faces of the figures reflecting the tension and anxiety of the period (plate 42).

42
Takeshisa Yumeji
Red Juban. Taisho Period.

Of all the printmakers of this group, by far the most popular, especially among foreign collectors, were two landscapists, Kawase Hasui (1883–1947) and his contemporary, Yoshida Hiroshi. Hasui, like Shinsui, had been a pupil of Kiyokata, but instead of taking up Japanese-style painting, he specialized in landscapes. He had a large oeuvre, embracing all aspects of Japanese scenery, from old Buddhist temples to famous country scenes, from the streets of Tokyo to sacred Mt. Fuji. In contrast to Hokusai and Hiroshige, the two great landscape artists of the Ukiyo-e school, Hasui made very detailed and realistic sketches on the spot, later translating them into woodblock prints in his studio. In spite of its typically Japanese subject matter, his work is Western in style, using light and shadow and illusionistic space (plates 43, 44).

This is even more true of Yoshida Hiroshi (1876–1950), who won early fame as a Western-style watercolorist. His prints were produced in the old manner, by professional artisans who cut the blocks and did the actual printing, but they are really closer to British watercolors than to traditional Japanese prints. Turning out a huge number over a long lifetime, he depicted not only his native country, but scenes from China, India, and Europe. In all these he reveals his keen sense of observation, seizing upon the most picturesque and characteristic aspects of the scene (plates 45, 46).

While the printmakers discussed above followed many traditional woodcut techniques, another group worked in a completely different manner, deeply in-

43
Kawase Hasui
Kiyosu Bridge, Tokyo. Taisho Period.

44
Kawase Hasui
Night over Takatsu in Osaka.
Taisho Period.

45
Yoshida Hiroshi
River View of Hayase. Showa Period.

46
Yoshida Hiroshi
Calm Wind. Showa Period.

fluenced by European ideals and practice. Beginning with the publication of the art magazine *Hosun* in 1907, this movement advocated the making of Hanga, or creative prints, for which the artist would not only draw the designs but cut and print his own blocks, instead of relying on professional craftsmen. Other magazines, such as *Shirakaba,* published essays on Edvard Munch, and reproduced the work of Toulouse-Lautrec, Munch, Vuillard, and the German Expressionists. Under the influence of these publications, Japanese artists began to make modern prints in the European manner. At first they experimented in

various media, such as lithography, etching, and wood engraving, but it was the latter which proved the most congenial. In 1918 this movement came to its maturity with the establishment of the Nippon Sosaku Kyokai, or Japan Creative Print Association.

This group, the first to devote itself entirely to Hanga artists, was organized by Yamamoto Kanae (1882–1946), who had studied modern prints in Europe and had been greatly influenced by the graphic art of Gauguin. Trained as a professional engraver, Yamamoto had made his first creative print as early as 1904 and was one of the founders of *Hosun* magazine. From 1912 to 1916 he lived in Paris, producing excellent work, remarkable for its freshness. After this promising beginning, however, and despite a very successful Hanga show held at Tokyo's Mitsukoshi Department Store in 1919, Yamamoto turned to other pursuits and ceased to play an important part in the Hanga movement.

The leadership of the Sosaku Hanga group then fell to the younger Onchi Koshiro (1891–1955). A native of Tokyo, he had been trained in oil painting at the Tokyo School of Fine Arts and was also an accomplished calligrapher. Early in his career, however, he had turned to printmaking, and had been active in the Hanga movement since his youth. He led the struggle for the recognition of Hanga as a medium equal to painting and calligraphy. His aims were realized when, after many years of struggle, the Tokyo School of Fine Arts added a department of engraving to its program, and the Imperial Art Institute included a print section in its annual exhibitions. Equally important was Onchi's role in introducing abstract art to Japan. As early as 1914, he wrote, "Abstract art is now, as it should be, the main way of art, and I hope that our civilization soon comes to realize this."[18]

48
Onchi Koshiro
Abstraction. Showa Period.

47
Onchi Koshiro
Portrait of Mioko. Showa Period.

49
Onchi Koshiro
Abstraction (My Own Dead Face). Showa Period.

Onchi's prints fall roughly into two main categories, representational and abstract, the second group dominating his later years. He was most influenced by Munch and Kandinsky, whose work he had seen in art magazines. Yet, despite the fact that he admired Western art and was influenced by European prints, Onchi remained strongly Japanese and showed in all his works a highly individual and typically Japanese sensibility. A lyrical artist, and a poet as well as a printmaker and book designer, Onchi gave his prints titles like "Lyric Number 13: Melancholy of Japan," or "Poem Number 8: Butterfly." Onchi used a great variety of materials in printing his works, employing anything which struck his fancy, such as bits of string, leaves, feathers, paper, glass, even rubber heels, often achieving very striking and original effects. His representational works are more conventional, among them his celebrated portrait of the poet Hagiwara and the lovely picture of his daughter, Mioko (plate 47). However, all his prints, whatever their style, reflect a sensitive and highly inventive artistic intelligence unique among Hanga artists (plates 48, 49).

The other leading member of the older generation of Hanga printmakers is Hiratsuka Yunichi, born in Matsue in 1895. At twenty-one, he went to Tokyo where he studied oil painting under the well known academic artist Okada Saburosuke. He soon discovered his love for woodcuts, however, and learned the craft from a traditional wood engraver. In contrast to Onchi who turned away from the Japanese tradition, Hiratsuka much admired the old Buddhist prints and always worked in black and white. As he has said, for him these are the most beautiful colors, and he believes that the most important element in the print is the expressive line.

His subjects also reflect his Japanese orientation. He has produced many prints depicting scenes from Japan, Korea and China as well as works with Buddhist subjects, his most popular print being a representation of the Buddhist priest Nichiren, of which he vowed to make ten thousand copies as a religious act. Typical of his work is his portrayal of a three storied pagoda in Nara (plate 50).

50
Hiratsuka Yunichi
Nara Pagoda. Showa Period.

51
Maekawa Sempan
Tanabata Festival. Showa Period.

A friend of Hiratsuka and Onchi was Maekawa Sempan (1888–1960), who was born in Kyoto but lived most of his life in Tokyo. During his early career he worked primarily as a successful illustrator, but he also became a member of the creative print movement and began to exhibit his work with the Hanga group. His prints deal primarily with traditional Japanese life, using subjects like hot springs, folk festivals and country inns. His Kyoto background is reflected in his more conservative outlook as well as in his use of soft colors and simple forms. His long years as an illustrator have also influenced his work; many of his best prints are woodcuts in books depicting various aspects of Japanese life (plate 51).

Two other outstanding Hanga artists of the older generation are Kawanishi Hide, born in Kobe in 1894 and Kawakami Sumio, a native of Yokohama (b. 1895). Kawanishi, who is primarily self taught, decided to take up printmaking after seeing a work by Yamamoto in an Osaka shop. Growing up in a port city where foreigners were common, Western people and Western things have always attracted Kawanishi, and he has also been very interested in Nagasaki prints which show foreign traders and their ships. But his most ardent love is for the circus, especially the European circuses he saw in Kobe. Many of his finest works are devoted to this theme, and a collection of his circus prints has an introduction by the German circus director Hagenbeck. Another well known series is his "One Hundred Views of Kobe," which has a special interest today because it shows many of the landmarks which were destroyed during the war (plate 52). Kawanishi works in bright colors with an emphasis on bold patterns which give his prints a gay, vibrant quality and a strong decorative appeal (plate 53).

52
Kawanishi Hide
Kobe. Showa Period.

53
Kawanishi Hide
Warm Day in Winter.
Showa Period.

54
Kawakami Sumio
Arrival of the Portuguese in Japan.
Showa Period.

Kawakami, who shares Kawanishi's enthusiasm for Western things, is also a native of a port city, a fact which is clearly reflected in his art. He is particularly interested both in the nineteenth century Westerners who arrived in Yokohama during the early Meiji period, and in those who came in the seventeenth century, whom the Japanese called Namban, or Southern Barbarians. Characteristically enough, one of his most famous prints is called "Namban Delight," a work which shows a Japanese man and woman reclining on a Western bed and smoking European pipes. Even more typical are his numerous prints showing scenes from the life of the early Meiji period when there was a great craze for everything Western. These often take the form of illustrated books in which the customs of those days are evoked with a good deal of nostalgia. In contrast to Kawanishi, who always uses brilliant colors, Kawakami tends more towards black and white, with a limited use of subdued color (plate 54).

55
Saito Kyoshi
Chinese Temple, Nagasaki. Showa Period.

56
Saito Kyoshi
Aizu in Winter. Showa Period.

In post-war Japan, Hanga has become such a popular art form that today several hundred print makers are active in this field. In recent years, many gifted woodcut artists have emerged and numerous exhibitions of modern Japanese prints have been held both in Japan and abroad. Of the artists working in a representational style, by far the most popular, especially among American Hanga enthusiasts, is Saito Kyoshi (born in 1907 in Otaru on the northern island of Hokkaido). At first he wanted to be an oil painter, but he turned to woodcuts after encountering the work of Munch and Gauguin. His early prints, such as "Winter in Aizu," tend towards the realistic, while his later works increasingly reflect the influence of the abstract movement. He is particularly fond of motifs taken from the art of ancient Japan, such as Haniwa, Buddhist images, old temples and rock gardens, and he portrays them with an emphasis on their picturesque forms and sense of pattern. The results are pictures which successfully combine elements derived from old Japan with abstract design (plates 55, 56).

Of the younger printmakers working in the abstract style, the finest is Yoshida Masaji (1917–1971). A graduate of the Tokyo School of Fine Arts, he studied painting with Fujishima and printmaking with Hiratsuka, but he did not emerge as an independent artist until he turned to abstraction under the influence of Onchi. His best work was done during the 1950's when he evolved a highly original style. Using blacks and greys and closely spaced parallel lines, he achieved a muted, melancholy effect which can be very moving, and it is not whimsey that leads him to entitle prints "Silence." Although the shapes are usually abstract, bordering on the non-objective, they often suggest natural forms, which gives them a universal quality. While most abstract Japanese prints tend toward the purely decorative, Yoshida Masaji's work has a depth of feeling and a subtle beauty all its own.

57
Munakata Shiko
Disciple of Buddha. Showa Period.

The most remarkable of all modern Japanese print-makers is Munakata Shiko, who was born the son of a blacksmith in Aomori in 1903, and died in Tokyo in 1975. His humble origin in provincial Japan is clearly reflected in his art. In addition to his prominence as a Hanga artist, he is also a leading member of the Japanese folk art movement. In fact, his prints, with their bold simple forms and dynamic expression, are closer in spirit to the Buddhist folk prints of traditional Japan than to the international style so typical of much of the graphic output of present-day Japan. But Munakata, who studied oil painting as a young man and even won prizes for his work in this field, is also profoundly influenced by Western art, especially Van Gogh, Renoir and the prints of the German Expressionists. At the same time he is deeply imbued with traditional Japanese ideals and is a devout Zen Buddhist, a fact which has a profound influence on his art. If there is one Japanese artist who has succeeded in fusing the art of the modern West with that of old Japan, it is Munakata. His unique style represents a harmonious synthesis of the two.

Munakata's "Ten Disciples of the Buddha," a masterful series of prints made in 1939, is a perfect illustration of this fusion of the modern with the traditional (plate 57), and so are his many illustrated books, which have a vigor and expressive power not found in the work of any other contemporary Japanese printmaker. Munakata's ouevre was enormous. Working rapidly, with little attention to fine detail, he turned out hundreds of bold, expressive prints representing Buddhist figures, female nudes, imaginary beings and landscapes (plate 58). His prints were usually black and white, but sometimes he added color which he applied with a brush to the back of the sheet. No other Japanese printmaker has won such acclaim:

58
Munakata Shiko
Woman with hawk. Showa Period.

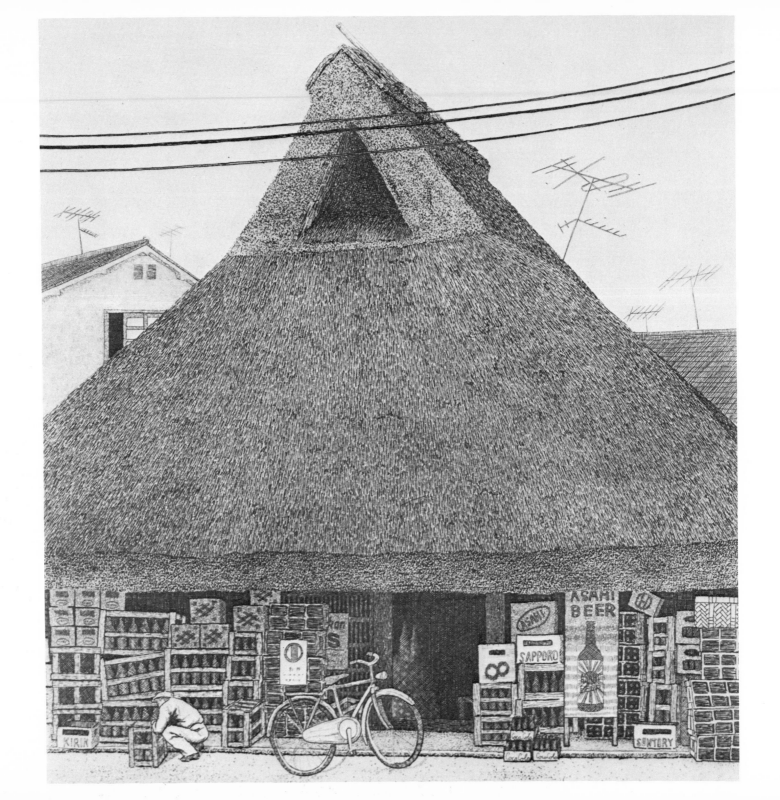

59
Tanaka Ryohei
Thatched Roof No. 10
Showa Period.

initially abroad with a first prize in the Lugano International Print Exhibition in 1951, an award in São Paulo in 1955 and a grand prix at the Venice Biennale of 1956; more recently in his own country where he was the first printmaker to have been designated a living cultural treasure of the Japanese nation.

The graphic media, other than woodcuts, have never played a very important role in Japan. In fact, etchings and lithographs were only introduced from the West in fairly recent times, and though many artists have experimented with them, there were few who have worked largely in these techniques. Among them, and by far the most outstanding, was an artist of the older generation, Oda Kazuma (1882–1956). Although using a different medium, Oda's work is similar to that of Hasui in portraying picturesque Japanese scenes in a realistic Western style. An early member of the creative print movement, Oda was active, along with Yamamoto, in arranging Hanga exhibitions and fighting for recognition of the graphic arts. Among those employing etching, the most outstanding is Tanaka Ryohei (b. 1933), who makes very sensitive prints of rural Japan in a detailed, realistic style (plate 59).

A very different artist, and by far the youngest of the printmakers discussed, is Ikeda Matsuo, who was born in Nagano in 1935 and grew up in the post-war period. A very sensitive and inventive artist, Ikeda is a product of the international phase of contemporary Japanese art. He owes his style not to any native tradition but to Surrealism and such artists as Klee, Miro and Dubuffet. Using delicate lines, subtle colors and strange images, his prints create a fantasy world which is highly original. Although still a young man, his achievement is considerable and he has been honored with all kinds of awards and exhibitions both in Japan and abroad, notably a one man show at the Museum of Modern Art in New York, a distinction given to very few Japanese artists. Yet his sensibility is not uniquely Japanese, suggesting that in prints as in painting the younger artists have become part of the burgeoning international art movement (plate 60).

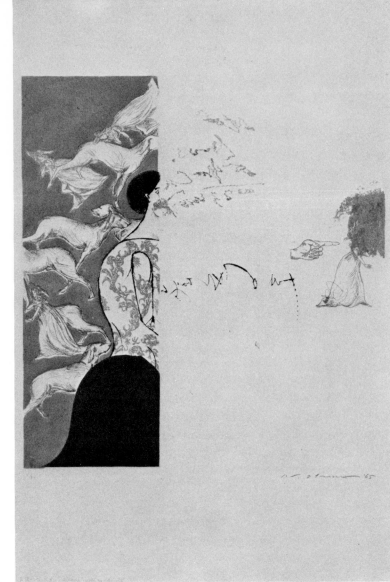

60
Ikeda Matsuo
Scene with an Angel. Showa Period.

Chapter 6
Modern
Japanese
Sculpture

During the Tokugawa period, Japanese sculpture suffered a serious decline. The Buddhist temples, long the chief patrons of sculpture, had lost much of their wealth and power, and when the feudal period came to an end, the skilled artisans who had been employed in making sword guards were no longer in demand. The same was true of the carvers of netsuke, whose products were no longer needed. Almost overnight professional sculptors of all kinds found the demand for their work vanishing, and the only way left to them to make a living was by producing ornamental figures, dolls and ivory carvings intended for the export trade. As the Japanese had always looked upon sculpture as a utilitarian craft rather than a fine art, when its religious and functional use disappeared, sculpture lost its reason for existence.

After the Meiji Restoration, the Japanese government invited the Italian sculptor Vincenzo Ragusa (1841–1927) to teach at the recently established Technological Art School. When he arrived in 1876 Ragusa took up teaching with great enthusiasm, and instructed his pupils in sketching, modelling in plaster, and carving in marble. Since there was no precedent for this kind of work, only a very few students enrolled and despite his earnest endeavors the program was discontinued after six years. Ragusa returned to Italy but several of his students continued their work and some of them became leading sculptors of the Meiji period. In addition to the impact of his teaching, Ragusa also left as a legacy the sculptures he had produced during his tenure. They were the first European sculptures ever seen in Japan, and they are still admired today by the public as well as by Japanese critics.

The pupil of Ragusa who became most famous and was already recognized as outstanding by Ragusa himself, was Okuma Ujihiro (1856–1934). He was the first student to master casting, and after his graduation he was employed in executing the architectural decorations at the Kasumigaseki Detached Palace. In 1888 he went to Europe to study at the Art Academy in Rome and visit Paris. Okuma's work, although rather

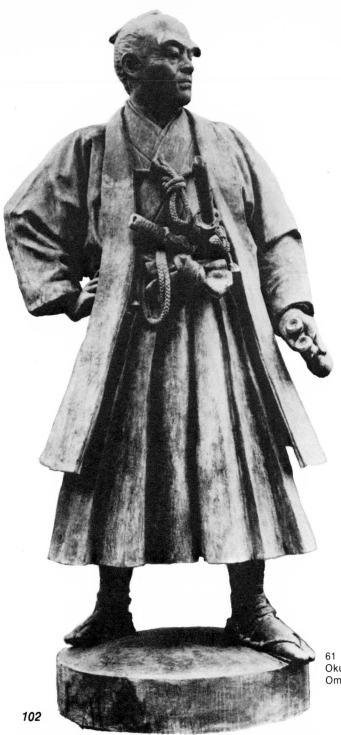

academic and by Western standards certainly not out-standing, had a great impact on the Japanese of the Meiji period; he was looked upon as a pioneer in the field. He also played a prominent role in the art life of Tokyo, serving on many juries, showing his work in numerous exhibitions and as a member of the Japan Art Association and various sculptural societies. His most famous work is the large bronze statue (erected in 1893) of the restoration leader Omura Masujiro which stands in front of the Yasukuni Shrine (plate 61).

Takamura Koun (1852–1934), although more closely associated with the Japanese tradition than Okuma, was also profoundly influenced by Western realism. Trained as a Buddhist carver, he continued to work primarily in wood throughout his life, but he handled it in a European, naturalistic manner. Koun was much impressed by the life-like drawings produced by Western artists, and he hoped to combine this quality with traditional Japanese wood carving. The result was an art not unlike that of his contemporary, Kano Hogai, and it is not surprising that it was much admired by Okakura and Fenollosa, who persuaded him to join the faculty of their new art school, where wood sculpture was part of the curriculum. Of his numerous works, the most famous are his representations of animals, notably his ''Old Monkey'' of 1893, now in the Tokyo National Museum (plates 62, 63).

61
Okuma Ujihiro
Omura Masuiro. Meiji Period.

62
Takamura Koun
Old Monkey Meiji Period.

63
Takamura Koun
Kusunoki Masashige.
Meiji Period.

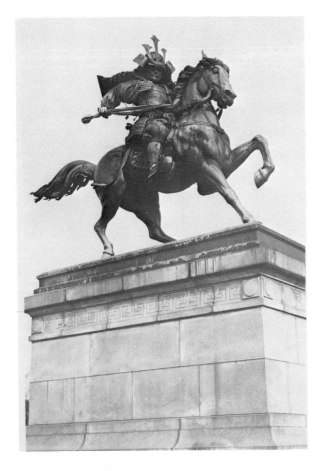

While the sculpture of the early Meiji period was influenced by European realism, the dominant influence on the late Meiji and Taisho period was the work of Auguste Rodin. No other Western artist has made such a profound impression on the Japanese. His fame in Japan started in 1900, when Japanese visitors to the Paris World Exposition were able to see a large retrospective of his work. Many articles about him appeared in various Japanese art magazines and his sculpture was widely reproduced. The extent to which the Japanese admired him is best illustrated by the stories of Ogiwara Morie, who had been trained as a painter and took up sculpture after seeing Rodin's "The Thinker" in Paris, and of Takamura Kotaro, who became a lifelong admirer of the French master after seeing a small reproduction of the same work in STUDIO. In 1910 the journal SHIRAKABA dedicated its November issue to Rodin in celebration of the artist's seventieth birthday, and sent him a gift of Japanese prints. In return, Rodin sent three of his works to the editors of the magazine who placed them on display, giving the Japanese public its first view of Rodin's work. These created a sensation among art lovers, profoundly influencing the development of modern Japanese sculpture.[19]

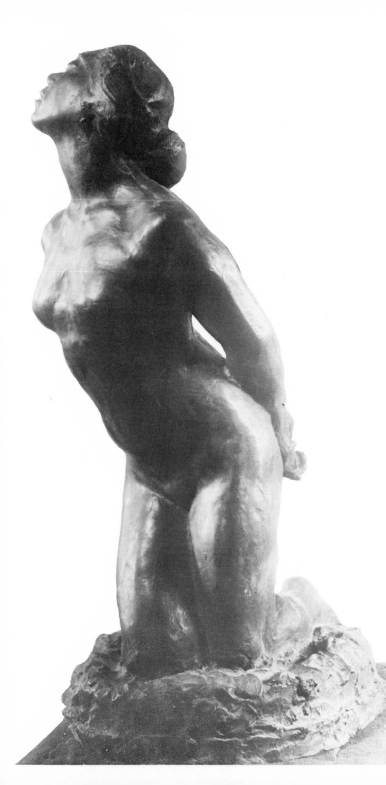

The young Japanese sculptor Ogiwara Morie (1879–1910) was profoundly influenced by Rodin, and helped to spread his fame in Japan through articles for leading art journals. Ogiwara's own work reflects Rodin's influence both in subject matter and in treatment of forms; unlike the earlier academic realist sculptors, Ogiwara's style was simple and impressionistic, with great emphasis on the expression of feeling. Typical of Ogiwara's impressionistic style is the portrait of Yanagi Keisuke, and his famous kneeling nude of 1910 (plate 64). His "Miner" of 1907, made in Paris only three years before Ogiwara's untimely death, is perhaps his most significant example of work produced under the influence of the French master.

64
Ogiwara Morie
Woman. Meiji Period.

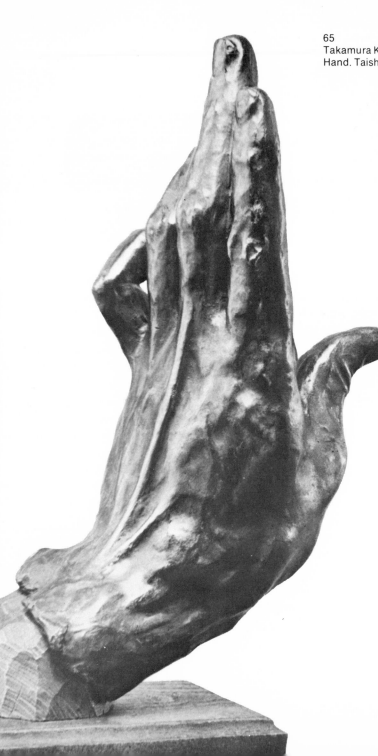

65
Takamura Kotaro
Hand. Taisho Period.

Takamura Kotaro (1883–1956), the son of the great Meiji artist, became the leading figure among the sculptors working in Rodin's tradition after the death of Ogiwara. He published a scholarly study of Rodin's life and work, which enjoyed wide popularity. Takamura was primarily active during the Taisho and early Showa periods. Working in bronze and specializing in the nude female figure, he set the precedent for the innumerable bronze images of nudes which dominated Japanese sculpture for the first half of the twentieth century. His sculpture, unlike that of his father, is wholly Western in both subject matter and style. His large bronze image of an upraised hand (plate 65), obviously based on Rodin's treatment of the same theme, and his portrait of his father, are among his best-known works.

During the Post-War period in Japan, sculptors began to explore newer and more revolutionary directions, stimulated by the International Movement. Many different trends, unlike the fairly static approach to sculpture earlier in the century, derived from various European and American sculptors. Brancusi, Arp, Moore, Calder, Smith, and Oldenburg all had their followers and imitators, resulting in a greater diversity of styles than had ever existed in Japanese sculpture. While the older sculptors were little more than provincial imitators of the European styles, the best of the contemporary artists managed to infuse the ideals and forms of modern art with a distinctly Japanese sensibility.

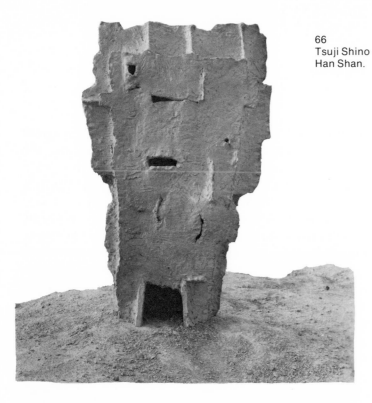

66
Tsuji Shino
Han Shan.

67
Nagare Masayuki
Returning. Showa Period.

The contemporary Japanese sculptor who is best known internationally is Nagare Masayuki, a native of Nagasaki who was born in 1923. Trained in the traditional arts and crafts, and deeply immersed in Zen Buddhism and Shintoism, Nagare is keenly aware of the Japanese traditions. While Tsuji was primarily influenced by the Haniwa of pre-historic Japan, Nagare is closer to the stone carvings of feudal Japan—the magnificent castle walls of Momoyama times and the stone lanterns and folk sculptures of the Edo period. At the same time, he is also influenced by abstract art, notably the work of Brancusi. Using strong, simple shapes and emphasizing the texture of the material, he creates beautifully designed sculptures which often have a haunting, magic quality. The names he gives his works—"Moon Drum," "Night Awakening," or "Machine for Magic," reveal his desire for this effect. In addition to individual pieces, Nagare has also executed large compositions, in particular his walls for the Japanese pavilion at the New York World's Fair of 1964 and his cement and stone floor and mural decorations for the Zenkyoren Building in Tokyo (plate 67).

This awareness of the native tradition is very evident in the work of Tsuji Shino, who was born in Tottori in 1910. Trained in Western-style painting and sculpture in Tokyo, Tsuji has been a professor of sculpture at the Kyoto College of Fine Arts since 1950. His work has received wide recognition not only in Japan, where he has won several important prizes, but also abroad, where his work was shown at the Venice Biennale of 1958 and at the Museum of Modern Art in New York. The very names of his sculptures, like 'Jomon' or 'Kanzan,' indicate his close relationship to his cultural heritage and his use of clay forms recalls those employed by the pre-historic sculptors of Japan (plate 66).

Mukai Ryokichi (b. 1918, Kyoto) is among the most important welded-metal sculptors. After graduating from The Tokyo School of Fine Arts, he studied in Paris from 1954 to 1955, but the most important influence on his art was the work of the sculptors of the New York School, particularly Roszak. Using cast and welded bronze, aluminum and various metal alloys, he creates complex and interesting works, some of which, like his insects of the 1960's, are quite remarkable. Delicate linear forms are employed along with flat metal surfaces, resulting in a sensitive and inventive use of the medium. Like Nagare he also works on a larger scale, as in his impressive mural for the Kinokuniya building in Tokyo and his monument for Ube City.

Among the sculptors of the post-war generation, by far the most original is Miki Tomio (b. 1937, Tokyo). A graduate of Tokyo Technical College, Miki works in metal, most often in cast aluminum. His style is best described as Neo-Dada, for his favorite motif is the human ear. Some are huge in scale; one is six feet high and weighs 490 pounds, while others are assembled in series on a panel. As he says, "... ears have become a persistent theme in [my] art and by placing them at regular intervals... I have caused them to become symbols. To me, the ear is a direct way to reject present reality. My choice of the ear for subject matter is compulsive; indeed, it is more correct to say that the ear chose me rather than that I chose the ear. To me the ear is a symbol of de-communication; through this symbol I indicate the absurdity and futility of a world in which communication is impossible."[20] Like the colossal detached ears in Bosch's "Garden of Delights," these strange objects have a surreal quality which points to a reality beyond themselves, something which haunts the world of our dreams.

Working in a radically different style is Teshigahara Sofu (b. 1900, Tokyo). He is best known as the master of the Sofu School of Ikebana, or flower arrangement, a group which he founded in 1927. Dissatisfied with the ephemeral nature of Ikebana, he began experimenting with sculptural forms, and came to recognize the spatial similarities of the two (see frontispiece). Teshigahara modernized the traditional art of Ikebana by combining flowers with abstract sculptural forms of wood, clay, brass and iron. Concurrent with his development of this unique modern style, he is famous both as a creative artist and as a master of the Sofu School. Beginning with a one-man show in Toyko in 1953, followed by a Paris exhibition in 1955 and a New York show in 1959, he has been recognized as an inventive sculptor who gives expression to the life forces of nature and uses organic materials in a new and expressive way.

Chapter 7
Modern
Japanese
Architecture

Traditional Japanese architecture is largely constructed of wood and tiles, with thatched roofs and paper sliding screens. The introduction of Western building techniques during the Meiji period thus represented a very basic change in both methods and materials of construction. Also, the concept of the architect as a professional engaged in the creation of a major work of art was an alien one to the Japanese. The carpenters and artisans who had built the traditional houses, temples, and palaces were never considered on a level with painters and calligraphers. Since the bulk of construction outside urban centers continued in the traditional styles, particularly in domestic architecture, the full impact of Western innovations was not immediately apparent. Over the succeeding decades, however, the transformation from Japanese-style to Western-style architecture was virtually complete.

Among the foreign teachers of architecture, T.J. Waters was the earliest significant figure. He arrived in Japan at the opening of the Meiji period, in 1868. His chief contribution was the design of the Osaka Mint, completed in 1871 and still standing. Constructed of brick faced with plaster and stone, it was a drastic departure from any previous style. It was followed by the construction of the main thoroughfare of Tokyo, extending from Shimbashi to Nihonbashi, called the Ginza. Lined with handsome brick buildings which housed the most prominent business establishments, the Ginza immediately became the most important street in Tokyo.

Among Western architects active during the early Meiji period were C. de Boinville, who designed the Foreign Office and the Technological College Auditorium, and G. V. Cappelletti, whose outstanding works were the Army Staff Office and the Army Memorial Hall, both completed in 1881. By far the most important influence, however, was Josiah Conder (1852–1920), who came to Japan as Professor of Architecture at the Technological College in 1887; his position, both as a practicing architect and as the teacher of a generation of Western-style architects, was of the greatest significance in the development of Japanese architecture. His design for the Ueno Museum (1882) and his famous Rokumeikan, a pretentious and costly brick structure intended for public social functions in the Western manner, were admired and influential. Among his later work, the Nicolai Cathedral of 1891, which is still standing, and the design for the Marunouchi Business district, were most important.

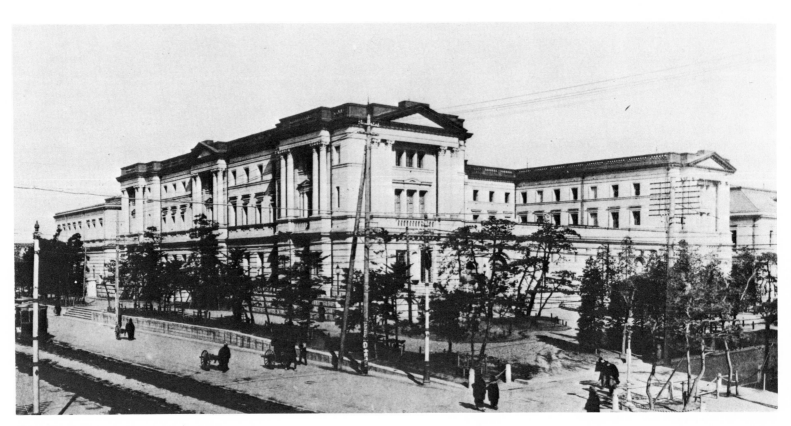

68
Tatsuno Kingo
Nihon Ginko (Bank of Japan), Tokyo. Meiji Period.

By the middle of the Meiji period Japanese architects, many of them trained in Germany, had mastered the new methods of construction, and had designed many important buildings. Pre-eminent among them was Tatsuno Kingo (1854–1919), an early graduate of the Technological College's Department of Architecture, and a student of the Royal Academy of Arts in London. A scholar of Japanese architecture, and a teacher at the Koka Daigaku, or Engineering College, Tatsuno built more than 280 structures. His greatest design, for the Bank of Japan (1896), was the result of a year's research on European and American bank architecture (plate 68). His other achievements include the huge Kokugikan Sumo Wrestling arena of 1909 and the Tokyo Station (1911–1914), built in the last years of the Meiji reign.

The new architecture was not only the work of foreigners. As early as 1868, Shimizu Kisuke built the Tsukiji Hotel, whose roomy apartments were described as equalling in comfort the finest hotels in Europe and America. Shimizu's Mitsui House, later the First National Bank, was erected in 1872, also heavily influenced by Western styles. Other early Meiji buildings in Western style were erected in Yokohama, Kobe, and Nagasaki, and gradually the style permeated the provincial areas. Still standing today is the Western-style elementary school built in 1875 in Nakagome, in Nagano prefecture. The Toyohira-kan, a handsome Western-style building, was erected in 1881 in Sapporo on Hokkaido.

Katayama Tokuma (1853–1917), principal architect of the Imperial Household, was responsible for the most ambitious and spectacular construction of the Meiji period, the Akasaka Detached Palace, completed in 1909. Modelled after Versailles, with elaborate marble and stucco interior decoration, and surrounded by spacious gardens with terraces, fountains, lawns, and flower beds, it is an impressive accomplishment, requiring ten years for completion, and still stands today (plate 69). Three other designs by Katayama, all large-scale brick and stone constructions, the Kyoto Museum (1895), the Nara Museum (1894), and the Hyokeikan (1909), the last today part of the Tokyo National Museum, are still among the largest and most impressive buildings in Japan today.

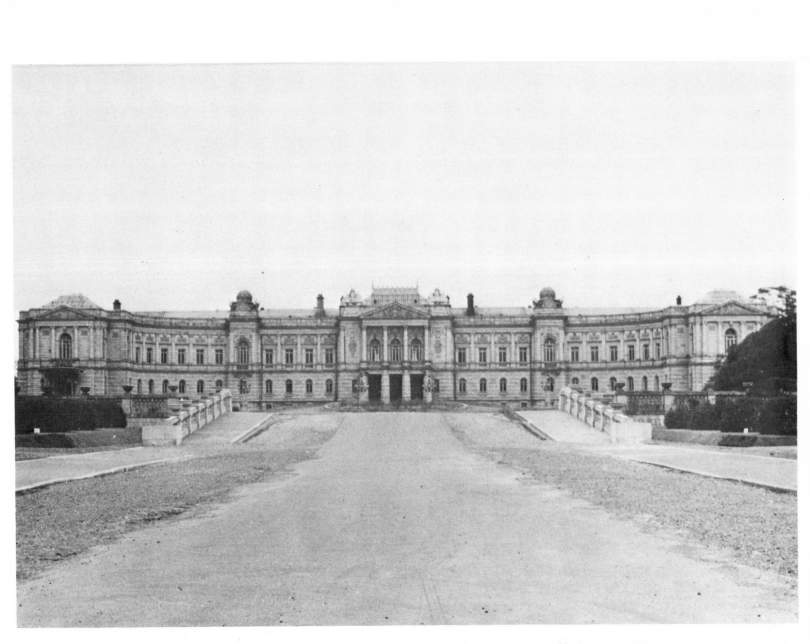

69
Katayama Tokuma
Akasaka Detached Palace, Tokyo. Meiji Period.

Unfortunately the Japanese discovered Western architecture at one of its weakest periods, essentially one of eclecticism, of imitation, which in turn was imitated by the Japanese: "The French Renaissance style was used in building a palace; a calm half-timber style for residences; the classical style for banks; the baroque for government offices; the Moorish for a museum." Every conceivable style of Western architecture was employed during this time, with less than satisfactory results, but the contemporary attempts to use an Oriental style for large-scale public building proved even less successful.

The traditional Japanese style continued only in private houses, Buddhist temples and Shinto shrines. In his *Impressions of Japanese Architecture,* the American architect Ralph Adams Cram gives a good summary of the prevailing styles of 1898: "Domestic work is still almost wholly on the old lines, so far as the middle classes are concerned. The nobles are building palaces from European designs that would dishonour a trans-Mississippi city or a German suburb. The public buildings designed by local 'foreign' architects are even worse, and the least offensive examples of Western styles are the works of natives, Nippon Ginko and Teitoku Hotel being fairly creditable examples of German classic. Occasionally important temples are built in the national style, conscientiously and with fine results in the case of the great Higashi Hong-anji temples in Kyoto, but usually in the bastard Shinto that marks the Tokyo Shokonsha."[21] Despite this point of view, which was somewhat biased, Western styles helped to shape the development of Japanese architecture and established a firmly-entrenched tradition.

It soon became apparent that the brick and stone construction employed for earlier Western-style buildings was not suitable for a country that had frequent earthquakes. The search for methods of earthquake-proof construction was accelerated after the large earthquake of 1901, resulting in the widespread use of American-style steel-frame construction, first used in Japan in 1895. By 1909, the first reinforced concrete buildings were constructed, and thereafter this material was employed in all multiple-storied buildings in large urban centers. The role of the engineer increased in importance, particularly after the great earthquake of 1923 destroyed most of downtown Tokyo and confirmed the necessity for earthquake-proof construction.

The Taisho period was a time of experimentation and new departure in architectural styles. In 1920 was founded the Bunriha, or Secessionist movement, whose founders, mostly the younger architects, were influenced by their modern German and Austrian counterparts. The functionalism and simplicity of design of Otto Wagner, Joseph Hoffmann, and Peter Behrens appealed to the young Japanese, who had equally rejected the eclectic, academic style of the nineteenth century. The Expressionist style, based on the work of Erich Mendelsohn and Hans Poelzig, was another major influence. The imaginative forms and often bizarre ornamentation of this group are reflected in some of the Taisho buildings. Frank Lloyd Wright contributed a number of important buildings at this time; the most significant (and best known) is the Imperial Hotel in Tokyo.

70
Okuma Kiho
Diet Building, Tokyo. Showa Period.

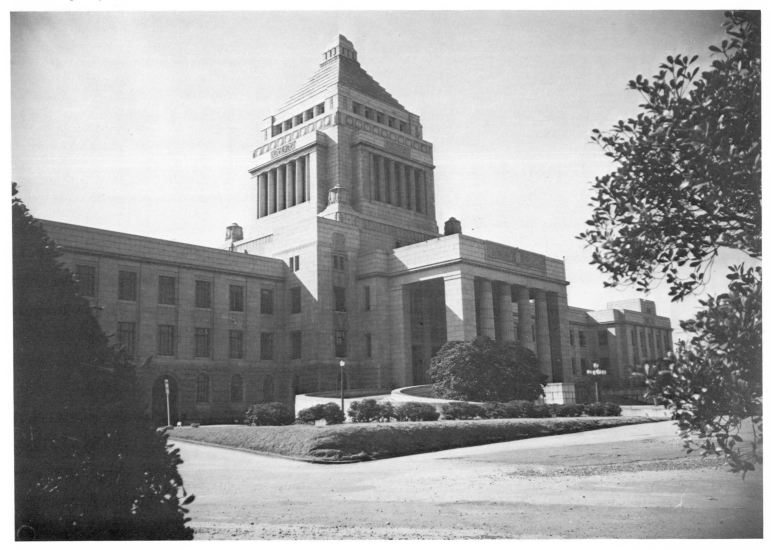

The most impressive structure of this period was the National Diet in Tokyo. Begun in 1920, the steel-frame construction and the arrangement of internal spaces was completed in 1927, but the entire structure was finished only in 1936. Designed under the direction of Professor Okuma Kiho of Tokyo University, and built by Japanese construction companies at a cost of twenty-five million yen, it was the most ambitious project yet undertaken in Japan. The foundations consisted of more than four thousand concrete piles on which were placed concrete caps holding steel frames and steel bars whose outer walls were faced with granite. The interior, decorated with marble, wood, textiles, gold, and lacquer, was the most splendid in Japan, and the massive forms of the exterior, while heavy and somewhat monotonous, are still very impressive (plate 70).

Far more interesting architecturally are the structures built under the sponsorship of the Ministry of Communications between 1922 and 1925. The most important of these was the Central Telegraph Office, built in the Art Nouveau style. The Ministry of Justice had sponsored a very modern design for the Kosuge Toyotama prison and in 1929 built the Kosuge prison, in which the influence of Mendelsohn's Expressionistic style is readily apparent. A good example of Wright's influence is the residence of the prime minister, constructed in 1928, with Western-style architecture in the public rooms and Japanese-style architecture for the private section. The numerous office buildings of that period, particularly the Marunouchi Building (1920–1923) and the Aoyama Apartments (1925–1927) reflect the Austrian school's emphasis on plain forms and functionalism.

Concurrent with the beginning of the Showa period in 1926, the work of the Bauhaus and the International style of architecture began to permeate Japanese architecture. One of the founders of the Bunriha, Horiguchi Sutemi, (b. 1895), visited the Bauhaus and met the leading German and Dutch architects. Two colleagues, Yamawaki Iwao and Yamaguchi Bunzo, studied with Gropius in Berlin. Maekawa Kunio and Sakakura Junzo, two of the best contemporary Japanese architects, studied with Le Corbusier. Tsuchiura Kameki and Endo Arata studied with Wright at Taliesin. The Japanese avant-garde architects, stimulated by these studies, began to work in the International Style in the 1930's, although their impact was at first quite limited.

71
Yoshida Tetsuro
Central Post Office, Tokyo. Showa Period.

Characteristic of the new style was the Wakasa House in Tokyo, a private residence built in 1937 by Horiguchi Sutemi, which closely resembles the early designs of Le Corbusier and the De Stijl group. Cubistic shapes, straight lines, plain surfaces, flat roof and flowing interior spaces proclaim the relationship of the new Japanese style to the European models. Steel, glass, and concrete further enhance the functionalism and abstract design. At the same time Horiguchi was designing houses closer to the native tradition, particularly the Okada House (1934) in Tokyo, in which the characteristic forms of domestic Japanese architecture are combined with modern forms and techniques.

The Tokyo Central Post Office (1927–1933) built by Yoshida Tetsuro (1894–1956) for the Department of Communications is the most celebrated example of the new style and a masterpiece of this most influential architect. Bruno Taut, who visited Japan in 1933, praised this structure as one of the masterpieces of modern architecture, embodying the essence of the new style with its severely functional forms devoid of all decoration (plate 71). Yoshida, like Horiguchi, was a pioneer in the introduction of new ideas and techniques, and at the same time was deeply involved in traditional forms of architecture. His two superb books on Japanese architecture, written in German and first published in Germany, are among the finest ever produced on the subject.

72
Furuhashi Ryutaro
Christ Church, Nara. Showa Period.

During this period of fevered experimentation with avant-garde European styles, the great mass of building continued to work in the old manner. Most peasant houses and domestic dwellings were built in traditional styles. The majority of the Japanese preferred to live on tatami matting without Western furniture, thus continuing the demand for old-style construction, both lighter and cheaper than Western models. Japanese-style was also used for Buddhist temples and Shinto shrines. Two of the best examples of modern Japanese religious architecture, the Meiji Shrine in Tokyo and the Heian Shrine in Kyoto, were built entirely in the traditional style. Traditional style was also used for lesser-known temples and shrines built in rural towns and villages. Attempts to use other models were less successful. The Indian-style Honganji Temple in the Tsukiji district of Tokyo, designed by Ito Chuta of Tokyo University and a notable scholar of oriental architecture, was not a totally pleasing effort. Christian churches, on the other hand, were built in a variety of Western styles, among which the most popular was Neo-Gothic. These buildings were much admired by the Japanese, particularly the Oura Catholic Church in Nagasaki, which is a National Treasure under government protection. There are some rare examples of churches built in Oriental Styles, particularly the Anglican church in Nara, in a Japanese Buddhist style (plate 72) and the Catholic church in Nara, in a Chinese style.

During the war years and the years immediately following there was little new building of any kind. Massive bombing virtually destroyed the large industrial centers, except for Kyoto, which was spared because of its historical and cultural significance. Tokyo was the hardest hit, with firebomb destruction of the entire central section. Here, as in the great earthquake of 1923, the traditional wooden buildings were more vulnerable, while the solidly-built reinforced-concrete structures were better able to withstand the bombing and subsequent fires.

Japan's period of recovery in the 1950s stimulated the resurgence of building activity and by the next decade Japan was established as one of the leaders in modern architecture. The dramatic advance was due largely to a small but dedicated group of European-trained, avant-garde architects. They had advocated advanced architectural concepts as early as twenty years before, but it was only in the more liberal and open post-war period that their ideas were translated into practice. The masters of the International Styles, especially Le Corbusier, Mies Van Der Rohe and Gropius, continued to influence them heavily, and to these were added Pier Luigi Nervi, Felix Candela, Eero Saarinen, and Paul Rudolph.

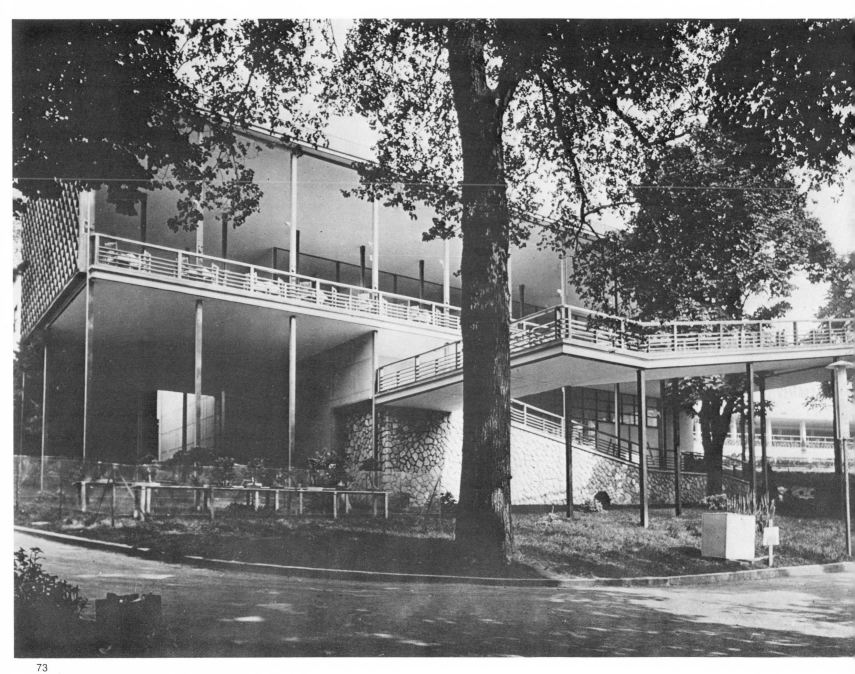

73
Sakakura Junzo
Japanese Pavilion, Paris Exposition of 1937. Showa Period.

The leading figures in the post-war architectural renaissance were born in the opening years of the twentieth century. Some, notably Sakakura and Maekawa, had been active before the war, while others, like Tange and Yoshimura, did not emerge into prominence until the post-war period. Working in a contemporary style and using modern building materials, especially reinforced concrete, these architects were particularly effective in public buildings, town halls, civic centers, university buildings, hospitals, and industrial and commercial structures. With very few exceptions, domestic architecture continued along the traditional path, and only in the large cities did Western-style apartment houses begin to appear, most of them quite undistinguished.

The most prominent architect of the pre-war period was Sakakura Junzo (b. 1904), usually regarded as the chief exponent of the architectural revival. A graduate of Tokyo University, Sakakura spent eight years in the atelier of Le Corbusier, who influenced him profoundly. Sakakura's first major work was the elegant Japanese Pavilion at the Paris Exposition of 1937, a striking example of Japanese International Style which won the grand prix of the Exposition (plate 73). His first important commission of the post-war period was the Museum of Modern Art in Kamakura. Built in 1952, it reflects the ideals of the Bauhaus in its simple cubic forms and clean lines, as well as in its extensive use of steel and glass. His more recent buildings are constructed in heavy concrete forms similar to those employed by Le Corbusier in his later work. Among these are Hajima Town Hall (1960), the Kure Municipal Hall (1962), and the Hiraoka City Hall and Civic Auditorium (1964), and most important, his collaboration with Maekawa and Le Corbusier on the National Museum of Western Art in Tokyo (1959).

Like Sakakura, Maekawa Kunio (b. 1905), considered by many Japan's greatest modern architect, studied in Tokyo at the University and in Paris with Le Corbusier. After two years in Europe Maekawa returned to Japan to work in the office of Wright's early colleague in Japan, Antonin Raimond. Maekawa combines his interest in and adherence to the principles of Le Corbusier and other European modernists with a profound love of traditional Japanese forms. Like Wright he recognizes the similarities between traditional Japanese models and modern styles and indeed, there can be no doubt that traditional Japanese architecture has played a significant part in the evolution of contemporary architectural principles.

Maekawa's career has been exceptionally productive. At the head of a team of young architects he has designed many of post-war Japan's outstanding buildings. Probably the most impressive is the Tokyo Metropolitan Festival Hall, built in 1961. An imposing structure of massive concrete forms and open spaces in imaginative design, it is perhaps the single finest example of contemporary architecture in Tokyo (plates 74, 75). Other notable examples of his civic architecture are the Fukushima Cultural Center (1954), the Setagaya Community Center (1957), and the Saitama Prefectural Cultural Hall (1966). A versatile artist with broad interests, Maekawa's work includes such diversified projects as the 1946 design for the "premo," a factory-produced dwelling, and the design for the Harumi Apartment House of 1958, which reflects the influence of Le Corbusier's Marseilles Unite d'Habitation. His design for the Japanese Pavilion of the Brussels International Exposition of 1938, like Sakakura's building of the previous year, introduced contemporary Japanese architecture to the Western world.

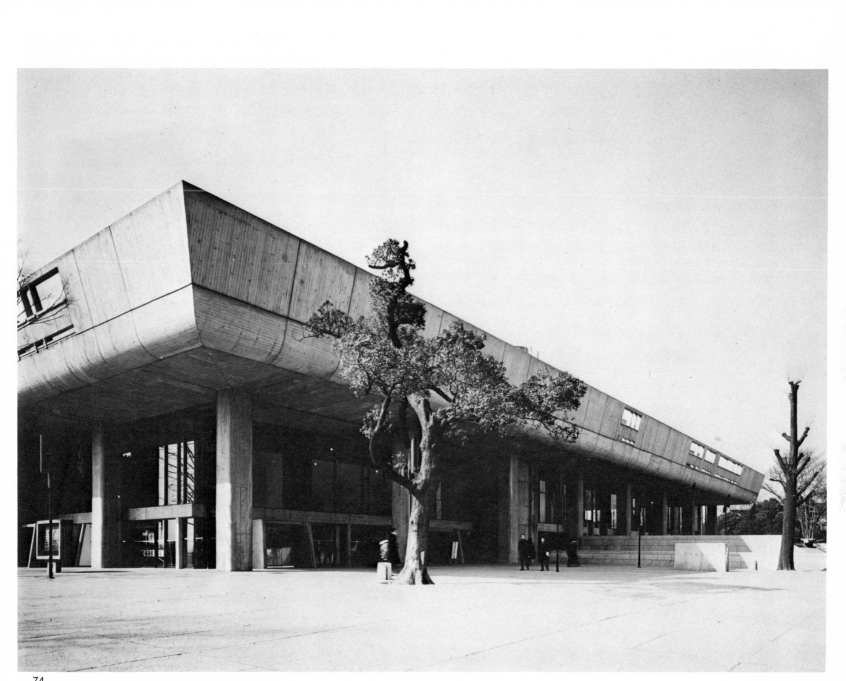

74
Maekawa Kunio
Tokyo Metropolitan Festival Hall. Showa Period.

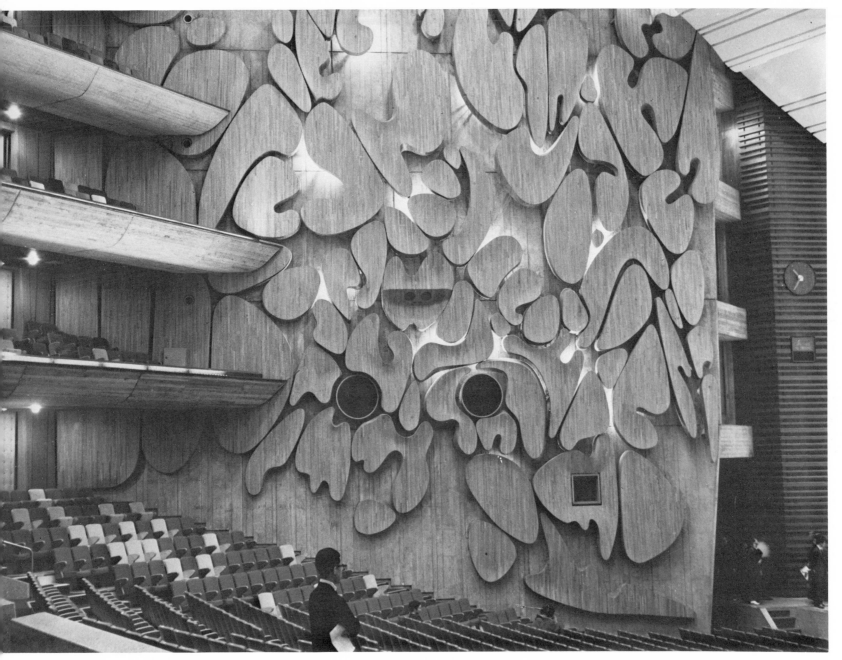

75
Maekawa Kunio
Tokyo Metropolitan Festival Hall. Showa Period.

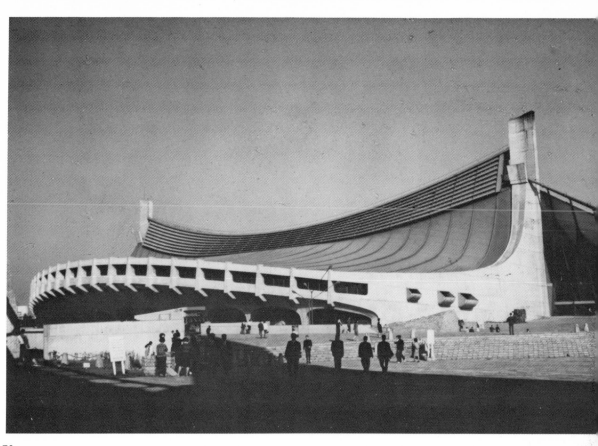

76
Kenzo Tange
Tokyo Olympic Swimming Pool. Showa Period.

It is Kenzo Tange (b. 1913), however, who has achieved the greatest international prominence among the contemporary Japanese architects. He completed the course at Tokyo University and continued his studies with Maekawa. Since his appointment in 1946 at the Tokyo University, he has influenced a generation of young architects. His first major project, the result of a competition, was the design for the Hiroshima Peace Hall (1949–1956) which immediately established his reputation. Although the influence of Le Corbusier is evident in Tange's work, his startling originality is everywhere apparent. An excellent example is his design for the Ehime Convention Center in Matsuyama (1952), in which shell concrete and plastic forms are used with great effectiveness. His own house in the outskirts of Tokyo combines a modern Western exterior with an interior of tatami matting, paper, and bamboo.

Tange's Kagawa Prefectural Office at Takamatsu (1955–1958) is a beautiful blend of Western and Japanese influences, with modern steel and concrete employed in a style reminiscent of the Shosoin in its jointing and crossing beams. Its Japanese rock garden adds to this effect. The most original of his designs in the last twenty years is the Olympic Stadium in Tokyo (1962–1964, plates 76, 77). The roof is suspended on steel cables, creating a vast interior space ideally suited for athletic competition. His Cathedral of St. Mary in Tokyo (1965) remains the most impressive and original church designed in Japan. Its huge concrete slab walls are twisted to form between them a skylight in the shape of a cross. His other massive concrete structure of that year, the Yamanishi Press and Radio Center at Kofu, seventy-five miles from Tokyo, is an excellent example of the architectural spirit of the 1960's.

Tange has worked and lectured extensively in the United States and Europe. He was Visiting Professor at the Massachusetts Institute of Technology from 1959 to 1960, and has been an active member of the International Congress of Modern Architecture since 1951. Among his important contributions to Western architecture is his design for the city plan of Skopje, Yugoslavia, the result of an international competition sponsored by the United Nations. His influence has

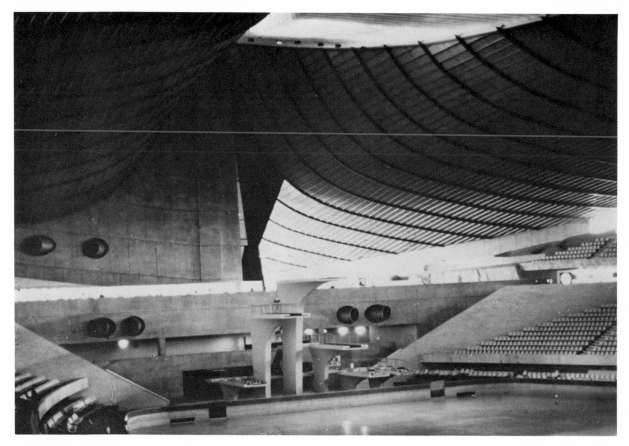

77
Kenzo Tange
Tokyo Olympic Swimming Pool (interior). Showa Period.

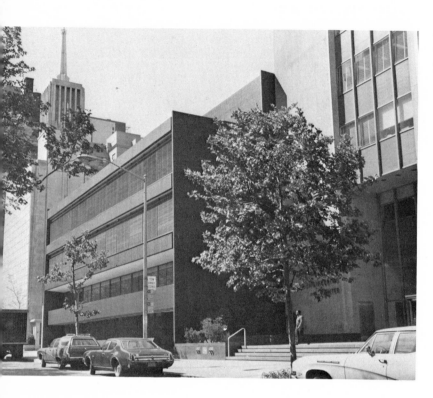

78
Yoshimura Junzo
Japan Society, New York. Showa Period.

been worldwide, and the many studies on him published throughout the world attest to Japan's contribution to contemporary art.

A number of contemporary architects have worked in somewhat more traditional styles, while employing modern building materials, particularly in the design of private houses and hotels. The most notable is Yoshimura Junzo (b. 1908). After the course at the Tokyo School of Fine Arts, Yoshimura gained experience in the office of Antonin Raimond. His deep interest in tea house architecture and the tea ceremony is reflected in the simplicity and calm of his architecture. Using tatami matting and shoji screens, his houses are subdued and elegant in atmosphere, while

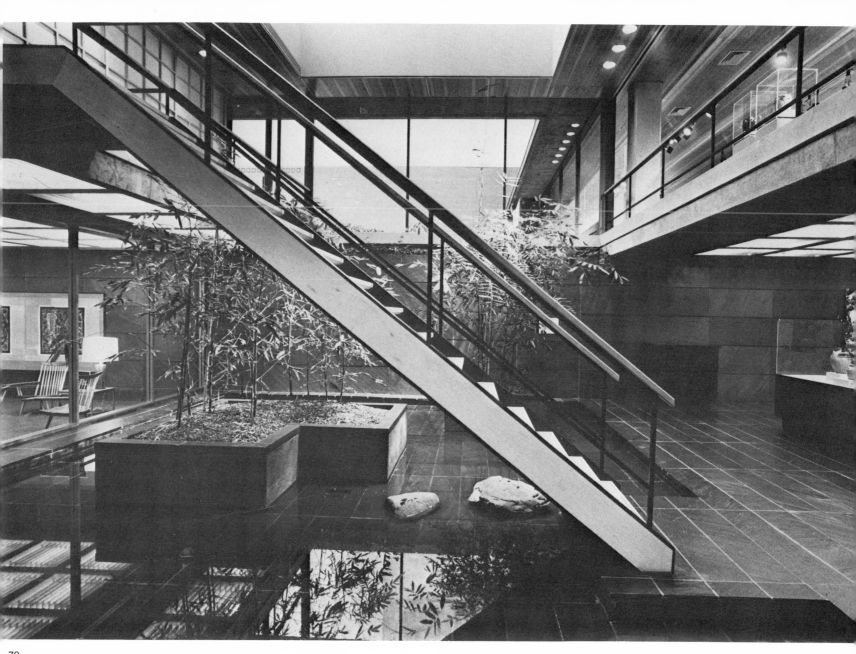

79
Yoshimura Junzo
Japan Society, New York (interior). Showa Period.

upon occasion augmented with Western-style furniture and bathrooms. His interiors are successfully related to their surroundings by the use of traditional Japanese gardens. Among his finest designs are the Higashiyama House (1953) and the Ikedayama House (1965). He is well-known in the United States for his designs of private Japanese houses in 1956, and for two excellent New York structures, the Museum of Modern Art and the headquarters of the Japan Society (1970, plates 78, 79). All his works are marked by serenity and simplicity in contrast to the more dynamic and expressive style of his contemporaries.

The limited space and large population of Japan have led to increasing study of the problems of city planning, land utilization, and mass housing among contemporary Japanese architects, and to the creation of many plans for urban renovation and expansion. The most famous is Tange's plan for the expansion of Tokyo, submitted in 1960. It outlines a linear city, lying across the sea between Tokyo and Yokohama, and stresses a new relationship between housing, work and recreation spaces, and traffic patterns. Younger artists in the Metabolism group, as they have come to be called, have suggested even more daring schemes, cities in the sky or underwater cities. Of those mass housing projects which were realized the most successful and aesthetically satisfying is the Sakuradai Village of Shozo Uchii, built in Yokohama in 1970. Its forty apartments form a unified group of individual modules, effectively related both to one another and to their landscape setting. Other experimentation in apartment clusters and prefabricated units has contributed significantly to the solution of the worldwide problems of urban planning.

Chapter 8
Modern
Japanese
Crafts

The traditional Japanese attitude toward craftsmen differed from Western attitudes, in that the foremost Japanese potters, calligraphers, and lacquer makers were regarded as equals of painters, who themselves often designed decorative objects. This tradition survives today, and is exemplified by the government's designation of certain performers and craftsmen as living national treasures. These artists are provided with a yearly stipend and a citation similar in intent to the British system of knighthood. Among those who have been so honored are potters, weavers and dyers, workers in lacquer and wood, and makers of iron tea kettles and swords. Some, like Hamada Shoji and Tomimoto Kenkichi, have achieved international prominence, while others continue to pursue traditional crafts in the obscurity of rural areas (plates 80, 81). This national award serves the twofold purpose of honoring the outstanding practitioners of many crafts and of perpetuating these traditions, "intangible legacies" of the Japanese nation, whose survival enriches both Japan and the rest of the world.

On the whole the Meiji Restoration and the opening of Japan to the West had an unfavorable effect on Japanese craftsmen. Artisans who had depended on the patronage of temples and feudal lords were thrown out of work, and the livelihood of thousands of inde-

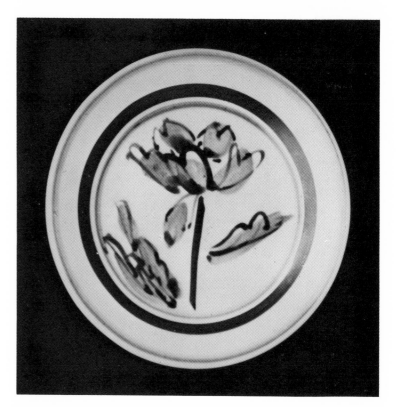

80
Tomimoto Kenkichi
Plate. Showa Period.

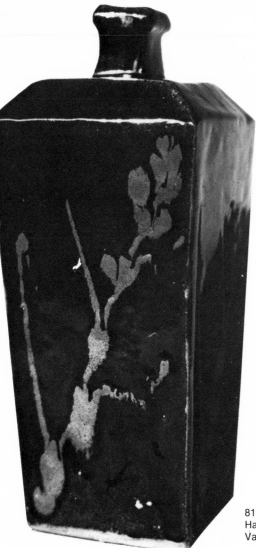

81
Hamada Shoji
Vase. Showa Period.

pendent craftsmen was sacrificed to changing fashions. This was especially true of metal workers, since the Samurai custom of carrying two swords as mark of their rank was abolished during the Meiji period. Glass mirrors quickly replaced the meticulous creations of workers in bronze, and the market for bronze bells and other artifacts for Buddhist temples declined steadily. The emphasis during the Tokugawa period on small-scale production of quality crafts for the artistic elite gave way to large-volume, cheaply-produced mass market goods, particularly for the export trade. The result was disastrous. Export wares were contemptuously referred to as "Yokohama-muke," or Yokohama direction, and were produced in a slipshod manner. Edward Morse's account of 1879 aptly describes the transformation: "Now the whole compound is given up to feverish activity, with Tom, Dick, and Harry and their children slapping it out by the gross. An order is given by the foreign agent for a hundred thousand cups and saucers. 'Put on all the red you can' is the order, as told to me by one agent, and the haste and roughness of the work, which is exported to America and Europe, confirms to the Japanese that they are dealing with a people whose tastes are barbaric. And yet these Japanese products are regarded as attractive in our country."[22]

At the same time Westerners were brought to Japan for the purpose of improving mass-production and increasing the export market. Dr. Gottfried Wagner, the German chemist, visited the great porcelain center of Arita at the invitation of the Japanese government, to introduce advanced production methods and industrial techniques. The result of his visit was Japan's emergence as the leading producer of ceramics in the modern world, with trained technicians turning out vast quantities of cheap china, flooding American and European markets. The ceramic industry provided thousands of jobs for workers in Arita, Nagoya, Kyoto, and the Tokyo area, and also served to destroy the local crafts, which could not compete with the inexpensive and efficient factories.

The government tried to encourage the production of high quality decorative objects, which were sent to European and American expositions. The Japanese participated in the Paris Exposition of 1867, but it was only at the Vienna Exposition of 1873 that Japanese crafts were exhibited on a large scale. The government allotted the enormous sum of five hundred sixty thousand yen for this ambitious project, and Japanese officials and craftsmen accompanied the display, in order to study modern methods of production

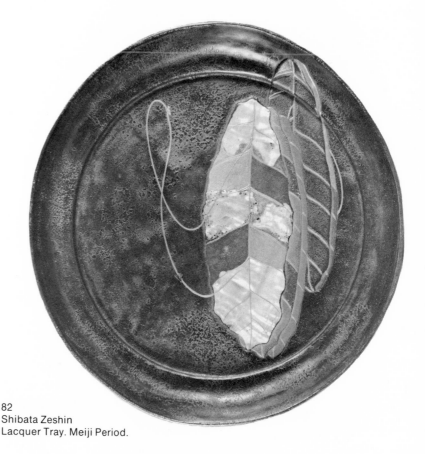

82
Shibata Zeshin
Lacquer Tray. Meiji Period.

and European styles. Although the quality of the display was quite inferior by traditional Japanese standards, it found an appreciative audience in the West and won many prizes. The English expert, Dr. Christopher Dresser, called the Japanese lacquers exhibited in 1878 "unequalled by any works that any people have produced."

The Meiji period was for the most part a very unproductive one for crafts. While the technical skill exhibited in objects of the period is certainly remarkable, the objects are aesthetically undistinguished, tending either toward the overly ornate or the uninteresting naturalistic.

There were a number of outstanding craftsmen working in the Meiji Period. Kano Natsu (1828–1898) was a skilled painter and metal worker, who engraved his designs on the surfaces of metal objects. Kato Tomotaro (1851–1916), the Seto potter, worked closely with Dr. Wagner, and developed new glazes and naturalistic decoration. The lacquer artist, Shibata Zeshin, had been trained as a painter of the Shijo schools, and used new realistic styles in the decoration of his lacquers (plates 82, 84). Textile production, traditionally an important Japanese craft, suffered a marked

83
Kitaoji Rosanjin
Oribe Jar. Showa Period.

decline as Western-style factory production replaced earlier hand methods. Japanese weavers turned to the production of large Gobelin-style tapestries with gaudy, naturalistic designs, whose only function was exhibition and international expositions. At the same time, thousands of unknown artisans throughout Japan continued to produce fine examples of ceramic, lacquer, textile, and metal work, keeping alive the skills and traditions of many generations. The unknown craftsmen in small towns and villages produced work aesthetically superior to that of their famous contemporaries.

A revival of traditional crafts occurred during the Taisho and early Showa periods, with the emergence of a remarkable group of craftsmen. Unlike their predecessors these artists did not come from traditional craft centers, and had not gone through the traditional apprenticeship of earlier craftsmen. Rather, their careers as craftsmen grew from earlier training as painters, architects, calligraphers, and writers. They were closer to the modern Western idea of the artist-craftsman than to the traditional Japanese models. Several of the best known have achieved prominence in the West, where their work is known through tours, exhibitions, and demonstrations. They are ma-

84
Shibata Zeshin
Writing Box. Meiji Period.

jor artists whose life and work has universal importance. Rosanjin perhaps exaggerated in the sign over his Tokyo shop, announcing "Rosanjin, Greatest Artist in Japan," but these artists, like their Western counterparts, regard their gifts as unique, and not as the culmination of a long tradition.

Kitaoji Rosanjin (1881–1959), one of the greatest artist-potters of modern Japan, aptly illustrates this trend. A controversial figure with a colorful personality, Rosanjin's many talents have made him a legend in his own time. Trained as a seal-engraver and calligrapher, he encountered the work of Takeuchi Seiho and was inspired by it to learn Japanese-style painting. In 1915, at the age of thirty-four, he turned to pottery and studied ceramics under the Kanazawa potter, Suda Seika. He opened an art shop in Tokyo, Taigado, in 1920, and five years later he established the Hoshigaoka Saryo restaurant, soon to become the most celebrated restaurant in Tokyo, where he supervised the cuisine. Also in 1925 he settled in Kita-Kamakura, built a kiln and had his first one-man show. Many other exhibitions followed, including an important show at the Museum of Modern Art in New York in 1954, culminating in a large retrospective in 1972 at the Japan House Gallery in New York.

85
Kitaoji Rosanjin
Shino Ware Vessel. Showa Period.

Rosanjin's huge ceramic output was remarkable for both its excellence and its diversity. Unlike most Japanese potters, who work in one style or tradition, Rosanjin's work ranges from fine porcelains decorated in cobalt blue to folk wares in the Iga and Shigaraki manner. His favorites were the tea wares of the Bizen, Oribe, or Shino type, in the tradition of the famous tea masters of the Momoyama period (plates 83, 85). Other works are reminiscent of the Kenzan school, Korean wares of the Yi dynasty, and old Chinese pottery. Rosanjin's pottery always blended the traditional styles with his own distinctive outlook.

Hamada Shoji, born in 1894 in Kawasaki, a suburb of Tokyo, is the other leading Japanese potter. He trained at the Tokyo Insitute of Technology, but it was not until 1920, inspired by the pottery of Mashiko in Tochigi prefecture, that he began to work in pottery. Also in 1920, he traveled to England with his friend Bernard Leach, and helped Leach establish a kiln for rural pottery at St. Ives in Cornwall. After four years in England he returned to Mashiko, where he has lived ever since. A great enthusiast for traditional Japanese and Korean folk art, Hamada was one of the founders of the Japan Folk Art Movement, and after the death of Dr. Soetsu Yanagi, he became the direc-

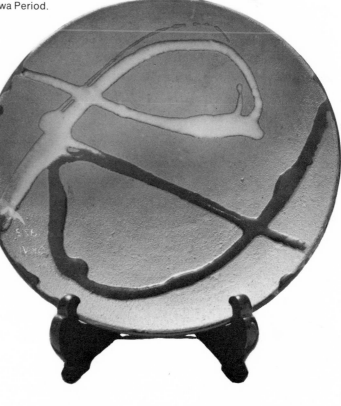

86
Hamada Shoji
Plate. Showa Period.

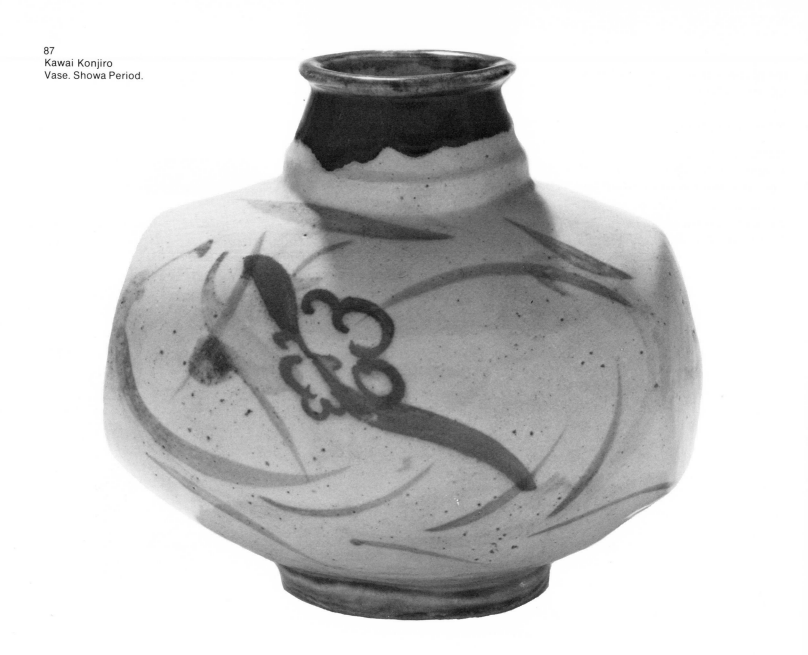

tor of the Tokyo Folk Art Museum. In 1955 he was designated a living national treasure for his contribution to folk pottery, and today he is probably the most famous living potter, not only in Japan, but in the world.

Hamada works in stoneware, in strong, simple shapes, with subdued colors and very stylized decoration. His work is influenced by the folk tradition of rural Japanese kilns, as well as English slipware and Korean pottery of the Yi dynasty, but he has brought to these varied styles a personal vision which has helped to shape a new tradition in folk pottery. This tradition, in turn, has had an enormous influence on both Japanese and Western crafts. His work combines the best of the Oriental tradition with a modern sensibility, creating an art which is honest and unpretentious, as the man himself, close to rural Japan and an expression of contemporary life (plates 86, 88).

A friend of Hamada and a co-founder of the Mingei, or Folk Art Movement, was Kawai Kanjiro (1890–1966). A native of Shimane prefecture, he was educated at the Tokyo Institute of Technology and became a professional potter in 1917. Like Hamada, Kawai was much attracted to the Korean pottery of the Yi dynasty, an influence clearly reflected in his work. A tireless experimenter and more of an intellectual than Hamada, Kawai has worked in many different styles and techniques. His best work was done during the thirties, and is outstanding for the beauty of its glazes and the fine quality of its painted designs (plate 87). In his later years he also made ceramic sculpture, including some very bold abstractions which are closer to the ceramics of Picasso and Miro than to anything in the Mingei tradition.

88
Hamada Shoji
Vase. Showa Period.

Tomimoto Kenkichi (1886–1963) was also associated for some time with the Mingei (plate 89). Trained as an architect, he began to work in ceramics under the influence of Bernard Leach. His early work, using crude, simple shapes and abstract designs, reflects his interest in Korean folk art. As a mature artist, however, he broke with the Mingei tradition and began to work in porcelain. His works were in the Chinese manner using pure white bodies and painted designs, usually in cobalt blue, but sometimes in bright colors with silver and gold. These sophisticated and refined wares are perhaps a legacy of the aristocratic tradition of the Kansai area where he was born and lived throughout his life. Tomimoto was designated a living national treasure of Japan, and his work is highly esteemed throughout the world.

Many of the finest contemporary wares are made for the tea ceremony, or cha-no-yu, an institution which has been one of the major patrons of Japanese pottery since the fifteenth century. The excellence of modern Japanese ceramics is undoubtedly due, in part at least, to the discriminating taste of the tea masters and the patronage they offer. Among the potters working in the distinctive style associated with cha-no-yu, the most famous is Arakawa Toyozo, born

89
Tomimoto Kenkichi
Mingei Style Plate. Showa Period.

in 1894 in the traditional pottery center of Tajimi in Gifu prefecture. Specializing in Shino and Black Seto wares, Arakawa is particularly admired for his beautiful Shino tea bowls, with their rough shapes and warm cream-colored glazes. Like Hamada, who was born in the same year, Arakawa was designated a living national treasure in 1955 (plate 90).

Of the many towns in Japan which have a long history of ceramic manufacture, the leader today is Imbe in Okayama prefecture, where Bizen ware has been manufactured since the Kamakura period (plate 91). In modern times there have been several excel-lent potters working in the Bizen tradition. The best-known is Kanishega Toyo (1896–1967), also a national treasure. The work of the Bizen potters is unique in the absence of glazes; it relies on the beauty and color of the baked Bizen clay, which is reddish-brown and has a high iron content. The surface designs are made with rice straw ropes which create areas of lighter colors. These ceramics, with their somber colors and quiet simplicity, have always appealed to the tea taste, and are among the strongest and most effective made in modern Japan (plate 92).

90
Arakawa Toyozo
Shino Tea Bowl. Showa Period.

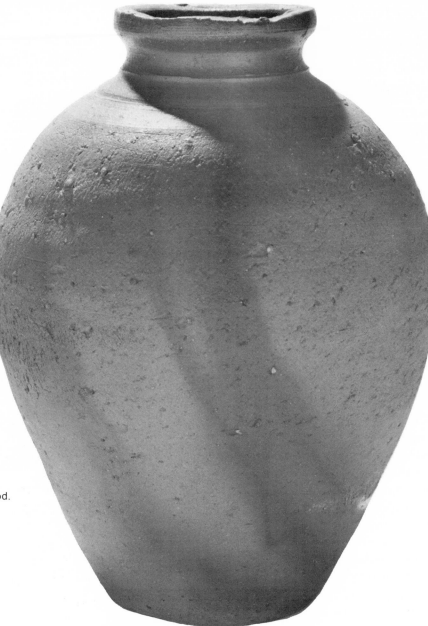

91
Fujiwara Kei
Bizen Ware Jar. Showa Period.

There are a number of modern potters who work in the style of Chinese ceramics. Both the stonewares and the porcelains of the Chinese have been much admired by traditional potters and have had considerable influence on the development of Japanese ceramics. The most accomplished ceramicist working in the Chinese manner, especially influenced by the Sung wares, was Itaya Hazan (1872–1963). Itaya came to maturity during the Meiji era but did much of his best work in the post-war period. His most important works were his green celadons and his white porcelains, often decorated with floral designs in colored enamel. Ishiguro Munemaro excels in the Chinese stoneware technique. Born in Toyama prefecture in 1893, he lives in Kyoto and has his small workshop in the village of Yase near the foot of Mt. Hiei. At the age of twenty-five, he saw a Chinese temmoku bowl which utterly entranced him, and from that time on his life was dedicated to the study of Chinese ceramics. His specialty is iron-glaze tea bowls and jars which combine the perfection of Sung ware with striking modern simplicity. Ishiguro has also been designated a living cultural treasure.

In contrast to these older men, many of the younger contemporary potters, coming to maturity in the post-war period, have taken for their inspiration the ceramic works of Picasso and Miro. A number of these potters have rejected the traditional Oriental view of ceramics as a basically utilitarian craft and instead have preferred to characterize themselves as fine artists. They emphasize individual expression and originality rather than traditional methods and styles, and their only interest in Japanese pottery is in the prehistoric Jomon pots with their bizarre shapes and strange decorations. It is too early to assess the achievement of the many young potters working in this style, but there is no doubt that they are making a vital contribution to Japanese ceramics.

92
Kaneshiga Toyo
Bizen Dish. Showa Period.

145

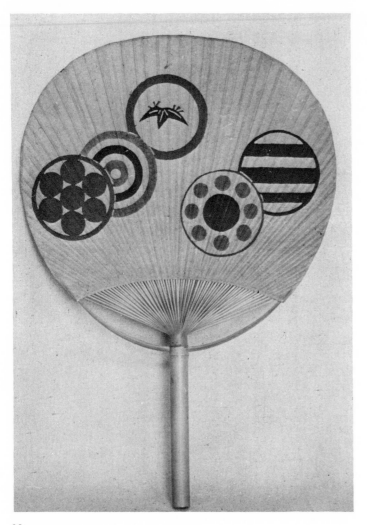

93
Serizawa Keisuke
Fan with stencil design. Showa Period.

At the opposite extreme are the folk potters still at work in many isolated rural communities. Although their number has diminished in this century, the efforts of Dr. Yanagi and the Mingei movement have brought about a modest revival in recent years. The best-known center for modern folk pottery is the village of Mashiko, but more genuine folk pottery is being made in Kyushu and in the Tohoku district, especially in the mountain villages of Onda and Koishibara, and in the vicinity of Kagoshima. As Dr. Yanagi has said, among these unpretentious common wares are some of the true masterpieces of modern Japanese pottery.

Textiles also had a marked revival during the Taisho and Showa periods. Textiles have always played a far more important role in the life of Japan than in most countries. In fact, of the craftsmen who have been designated living cultural treasures since 1950, no fewer than twenty-one have devoted their lives to the study and practice of traditional weaving and dyeing. Their output is very limited when compared to the huge volume of machine-made textiles, but there has been a steady demand for their products in spite of the high prices they command, and there is no doubt that their place in Japanese artistic life is secure. Japan is probably the only country in the world where outstanding weavers and dyers enjoy a fame equal to that of painters, sculptors, and architects, and where people are willing to pay thousands of dollars for an outstanding example of textile art.

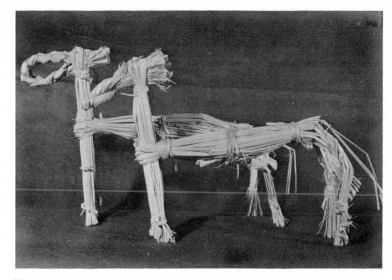

94
Straw Horses from Nagano
Prefecture. Showa Period.

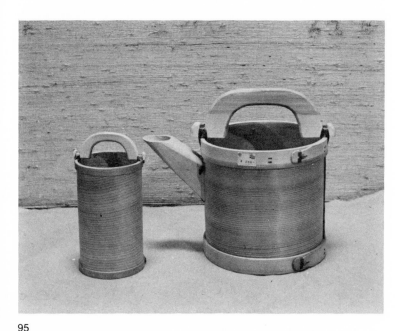

95
Modern Folk Art Vessels from
Fukushima Prefecture. Showa Period.

Among those honored by the nation, there are two remarkable artists whose very different techniques and backgrounds represent two main trends in contemporary Japanese textile production. The first is the traditional Kyoto weaver Kitagawa Heiro (b. 1898), a seventeenth-generation descendent of the famous textile house of Tawaraya; the other, Serizawa Keisuke, born in 1895 in Shizuoka, is one of the leaders of the Mingei movement, along with Hamada and Yanagi. Kitagawa, whose family has been in the textile business since 1467, first studied painting, but in 1927 he succeeded his father as the master of the Tawaraya establishment. His specialties are silk damasks and brocades in the manner of the Nara and Heian periods, and a silk gauze which was first made in the seventh century, but fell into disuse after the eighth. He has been cited twice for his contribution to the textile arts, first in 1956, and again in 1960. Serizawa is best known for his bingata, or stencil and dye designs, based on the traditional folk textiles of the Ryuku islands. His work in the modern folk art style enjoys great popularity, and includes, in addition to textile designs, screens, calendars, fans, and book covers (plate 93). A teacher as well as a remarkable creative artist, Serizawa is the very essence of the artist-craftsman, and has had a tremendous influence on the younger generation.

The Japanese art of lacquer, which had already declined during the Meiji period, has never recovered its central position in Japanese crafts, although lacquer

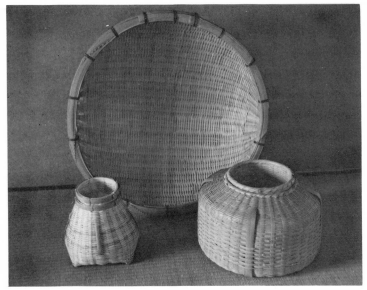

96
Folk Baskets from rural Japan. Showa Period.

as a material is still widely used in Japan. At his coronation in 1928, the Emperor presented lacquer souvenirs to the members of the Imperial family, and gave four hundred thousand vermillion-colored gold makie lacquer sake cups to those of his subjects who had reached the age of seventy. But lacquer as an art form has ceased to play a major role in contemporary Japan. Ogawa Masataka, the well-known art critic, has written in *The Enduring Crafts of Japan,* "It was the arrival of Japan's modern period, just a century ago, that brought Japanese lacquer ware to its position of renown in the West. Ironically, however, this same event marked the beginning of the disastrous decline in the craft itself, which could not compete with the machine in turning out large quantities of relatively inexpensive products like those which have more and

more replaced the traditional lacquer ware of the past. It is a regrettable fact that the craft is most inactive in present day Japan, and in many ways has the aspects of a dying art."[23]

The most important contemporary lacquer worker is Matsuda Genroku, designated a living cultural treasure in 1955. Born in 1896 in Kanazawa in Ishikawa prefecture, one of the great centers of traditional lacquer manufacture, Matsuda has devoted his life to furthering traditional crafts. He studied at the Tokyo School of Fine Arts, and has taught there for many years. He is a highly accomplished craftsman in the makie technique, in which gold and silver dust is sprinkled on the lacquered surface. Matsuda combines the traditional makie with modern designs, as in his decorations of the interiors of several pre-war Japanese ocean liners. His best works are the beautiful lacquer boxes decorated with stylized birds, flowers, and leaves, executed in makie, and blending the traditional and modern elements with unusual sensitivity. There is a school of modern artists using lacquer in a purely pictorial way, much as Zeshin had done in the Meiji period. They are really painters who use lacquer instead of more traditional pigments.

The Japanese metal crafts have also declined, and today they play a relatively minor role compared to their earlier prominence. Modern industrial designers continue to use all kinds of metals, but the traditional crafts of bronze casting and iron forging have lost most of their importance. Swords and sword imple-

97
Iron Kettle from Iwate
Prefecture. Showa Period.

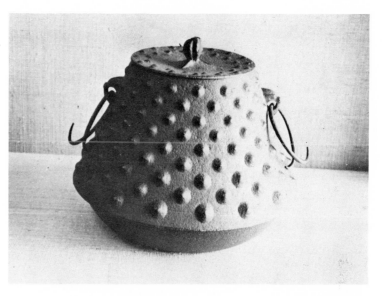

ments are still made in some craft centers, and several swordsmiths have been designated living cultural treasures, but the only field in which metal work is still important is in the production of iron tea kettles made for the tea ceremony. These kettles, in a variety of shapes and textures, are often works of real merit, which compare favorably with earlier examples. Here again, the patronage of the tea masters has been a decisive factor, for they alone are willing to pay the high prices which first-rate tea kettles command (plate 97). The most celebrated maker of iron kettles for cha-no-yu is Nagano Tetsushi. He was born in 1901 in Nagoya and has his foundry in Yamagata, a traditional center of iron work. Nagano uses iron sand instead of the usual pig iron, and has produced vessels noted for their thin walls, fine shapes, and beautiful texture. He was designated a living cultural treasure in 1963.

There are a large number of unknown, uncelebrated craftsmen and designers in Japan today whose works still reflect the pride in good workmanship and the keen sensibility which has characterized Japanese crafts over many centuries. These true folk artists make paper, folk toys, straw baskets, lacquer bowls, hand-woven cloth, metal utensils, and wooden objects (plates 94, 95, 96). Some are artisans working in traditional crafts, and others are industrial designers who are making a uniquely Japanese contribution to their various fields. While painting, sculpture, and modern architecture have become increasingly marked by the dominant Western influence, it is in the crafts alone that something truly Japanese continues to survive, and it may well be that long after the peculiarly Japanese sensibility has ceased to express itself in the so-called fine arts, the kimonos, ceramics, and other objects made by craftsmen will reflect the unique artistic heritage of Japan.

Notes

p. 17 1. R. Storry, *A Short History of Modern Japan* (London, 1960), p. 166.

p. 19 2. *Ibid.*

p. 20 3. K. Okakura, *The Awakening of Japan* (New York, 1904), pp. 6-7.

p. 20 4. *Ibid.*

p. 21 5. S. Yoshida, in *Britannica Book of the Year* (1977), p. 24.

p. 21 6. D. Keene, *Modern Japanese Literature* (New York, 1956), p. 17.

p. 22 7. *Ibid.*

p. 25 8. R. Storry, *op. cit.*

p. 26 9. E. Seidensticker, in the Introduction to Tanizaki's *Some Prefer Nettles* (Tokyo, 1955), p. ix.

p. 27 10. W.J. de Bary, *Sources of Japanese Tradition* (New York, 1958), pp. 784-95.

p. 31 11. T. Nakamura, *Contemporary Japanese Style Painting* (New York, 1962), p. 20.

p. 34 12. J. Rosenfield in *Tradition and Modernization in Japanese Culture*, ed. D. Shively (Princeton, 1971), pp. 218-9.

p. 35 13. T. Odakane, *Tessai, Master of the Literati Style* (Tokyo and Palo Alto, 1965), p. 46.

p. 51 14. T. Nakamura, *op. cit.*, p. 26.

p. 58 15. T. Kagesato, "Yorozu Tetsugoro," in *Bitjutsu Kenkyu* Nos. 255, 258, 262, 273.

p. 61 16. D. Kung, *The Contemporary Artist in Japan* (Honolulu, 1966), p. 137.

p. 70 17. Y. Tono, in *New Art Around the World* (New York, 1966), p. 232.

p. 84 18. O. Statler, *Modern Japanese Prints* (Tokyo and Rutland, 1956), p. 24.

p. 104 19. D. Nakamura, "Rodin in Japan," in *Bijutsu Kenkuy*, 1951.

p. 108 20. D. Kung, *op. cit.*, p. 173.

p. 115 21. R.A. Cram, *Impressions of Japanese Architecture* (New York, 1905), p. 71.

p. 134 22. E.S. Morse, *Japan Day by Day* (Boston, 1917), p. 187.

p. 148 23. M. Ogawa, *The Enduring Crafts of Japan* (Tokyo, 1968), p. 124.

Bibliography

General Books on Modern Japanese History, Culture and Art

Alcock, R. Art and Art Industries in Japan. London, 1878.

Borton, H. Japan's Modern Century. New York, 1955.

Brinkley, F. Japan Vol. VII: Pictorial and Applied Art. Boston, 1902.

Dresser, C. Japan, Its Architecture, Art and Art Manufactures. London, 1882.

Ienaga, S. History of Japan. Tokyo, 1953.

Nitobe, I. Western Influences in Modern Japan. Chicago, 1931.

Okakura, Y. The Japanese Spirit. London, 1905.

Pictorial Encyclopaedia of the Oriental Arts: Japan, Vol. 4. Tokyo and New York, 1969.

Sekai Bijutsu Zenshu, Vols. 25 and 28. Tokyo, 1951 and 1955.

Shively, D. Tradition and Modernization in Japanese Culture. Princeton, 1971.

Storry, R. A History of Modern Japan. Harmondsworth, 1960.

Tominaga, S. ed. Nihon Bijutsu Taikei Vol. X. Tokyo, 1961.

Tono, Y. Japan in New Art Around the World. New York, 1966.

Uyeno, N. Japanese Arts and Crafts in the Meiji Era. Tokyo, 1958.

Who's Who Among Japanese Artists. Tokyo, 1961.

Yanaga, C. Japan Since Perry. New York, 1949.

Year Book of Japanese Art, Vol. 1927, Nos. 28, 29–30. Tokyo, 1927–30.

Books on Modern Japanese Painting and Sculpture

Elisseev, S. La Peinture Contemporaine Au Japon. Paris, 1923.

Contemporary Japanese Art. Guggenheim Museum, New York, 1970.

Imaizumi, A. The Sculpture of Sofu Teshigahara. Tokyo, 1968.

Kawakita, M. Modern Japanese Painting. Tokyo, 1955.

Kawakita, M. Kokei. Tokyo and Rutland, 1956.

Kobayashi, S. Hashimoto Gaho. Tokyo, 1904.

Kumamoto, K. Western Style Painting in Japan During the Middle Part of the Meiji Period. Bijutsu Kenkyo Nos. 188, 192, 201, 206.

Lieberman, W. The New Japanese Painting and Sculpture. New York, 1966.

Miyagawa, T. Modern Japanese Painting. Tokyo and Palo Alto, 1967.

Nakamura, T. Contemporary Japanese Style Painting. New York, 1969.

Noma, S. Yokoyama Taikan. Tokyo and Rutland, 1956.

Odakane, T. Tessai, Master of the Literati Style. Tokyo, 1956.

Takahashi, S. Gyokudo Kawai. Tokyo, 1958.

Tapie, M. and Haga, T. Continuite Et Avant-Garde Au Japon. Torino, 1961.

Yashiro, Y. Japanische Malerei der Gegenwart. Berlin, 1931.

Yoshizawa, C. Taikan, Modern Master of Oriental Style Painting. Tokyo, 1962.

Books on
Modern Japanese Prints

Fujikake, S. Japanese Woodblock Prints. Tokyo, 1957 (new ed.).
Kawakita, M. Contemporary Japanese Prints. Tokyo, 1967.
Lane, R. Masters of the Japanese Print. London, 1962.
Michener, J. The Modern Japanese Print. Tokyo, 1962.
Modern Japanese Prints. Toledo Museum of Art, Toledo, 1936.
Onchi Exhibition Catalogue. California Palace of the Legion of
 Honor Museum, San Francisco, 1964.
Statler, O. Modern Japanese Prints. Tokyo and Rutland, 1956.
A Special Exhibition of Modern Japanese Prints. Toledo Museum
 of Art, Toledo, 1930.
Tamba, T. Yokohama Ukiyoe. Tokyo, 1962.
Yanagi. S. ed. Munakata Shiko. Tokyo, 1958.
Yoshida, S. Kiyochika. Tokyo, 1904.

Books on Modern
Japanese Architecture

Altherr, A. Three Japanese Architects. New York, 1968.
Boyd, R. New Directions in Japanese Architecture. New York, 1968.
Boyd, R. Kenzo Tange. New York, 1962.
Kawazoe, N. Contemporary Japanese Architecture. Tokyo, 1968.
Koike, S. Contemporary Architecture of Japan. Tokyo, 1953.
Koike, S. Japan's New Architecture. Tokyo, 1956.
Kishida, H. Japanese Architecture. Tokyo, 1953 (revised ed.).
Japan Times and Mail. Architectural Japan. Tokyo, 1936.
Kultermann, U. New Japanese Architecture. New York, 1967.
Riani, P. Kenzo Tange. Firenze, 1969.

Books on Modern
Japanese Crafts

Cardozo, S. Rosanjin. New York, 1972.
Mitsuoka, T. Ceramic Art of Japan. Tokyo, 1949.
Munsterberg, H. The Ceramic Art of Japan. Tokyo and Rutland,
 1958.
Munsterberg, H. The Folk Arts of Japan. Tokyo and Rutland, 1958.
Ogawa, M. The Enduring Crafts of Japan. Tokyo and New York,
 1968.

Okada, Y. Japanese Handicrafts. Tokyo, 1956.
Rague, B.V. Geschichte der Japanischen Lackkunst. Berlin, 1967.
Sanders, H. The World of Japanese Ceramics. Tokyo and Palo Alto,
 1967.
Tomimoto Kenkichi. Tokyo, 1964.
Yanagi, S. Hamada Shoji. Tokyo, 1961.
Yoshida, K. The Ceramic Art of Kitaoji Rosanjin. Tokyo, 1964.
Yoshino, T. Japanese Lacquer Art. Tokyo, 1959.

Index

Picture Credits

Teshigahara Sofu
Abstract Sculpture
Collection the artist, Tokyo

Kano Hogai
Kannon
Tokyo University of the Arts

Kano Hogai
Landscape
Freer Gallery, Washington, D.C.

Kano Hogai
Kanzan and Jittoku
Freer Gallery, Washington, D.C.

Tomioka Tessai
Jugyu-zu
National Museum, Tokyo

Tomioka Tessai
Dragon
National Museum, Tokyo

Yokoyama Taikan
Mt. Kisen
Yamatane Museum, Tokyo

Hishida Shunso
Fallen Leaves
National Museum, Tokyo

Shimomura Kanzan
Yoroboshi Screens
National Museum, Tokyo

Shimomura Kanzan
Pair of screens with pine trees and wisteria
Yamatane Museum, Tokyo

Shimomura Kanzan
Pair of screens with pine trees and wisteria
Yamatane Museum, Tokyo

Kobayashi Kokei
The Tale of Kiyohime
Yamatane Museum, Tokyo

Maeda Seison
Views of Kyoto
National Museum, Tokyo

Maeda Seison
Views of Kyoto
National Museum, Tokyo

Kaburagi Kiyokata
Tsukiji Akashicho
Private collection, Tokyo

Kawai Gyokudo
Landscape After a Shower
Yamatane Museum, Tokyo

Takeuchi Seiho
Landscape
Collection Alice Boney, New York

Takeuchi Seiho
Landscape
Collection Alice Boney, New York

Uemura Shoen
Waiting for the Moon
Private collection, Tokyo

Kawabata Ryushi
Music of Spring Trees
Ryushi Memorial Gallery, Tokyo

Ogawa Gaboku
Abstract calligraphy
Collection the author

Ogawa Gaboku
Abstract calligraphy
Collection the artist

Takahashi Yuichi
Salmon
Tokyo University of the Arts

Kuroda Seiki
Lakeside
National Cultural Property Institute, Tokyo

Umehara Ryuzaburo
Man with Landscape
Private collection, Tokyo

Yasui Sotaro
Grand-daughter
Ohara Museum, Kura-shiki

Yasui Sotaro
Landscape
Private collection, Tokyo

Saito Yoshishige
Abstraction
Private collection, Tokyo

Okada Kenzo
Posterity
Betty Parsons Gallery, New York

Sugai Kumi
Autoroute au Soleil
Lefebre Gallery, New York

Migishi Setsuko
Goldfish
Private collection, Tokyo

Tanaka Tatsuo
Christ among Prisoners
Collection the author

Katsura Yukiko
Red and White
Collection the artist

Katsura Yukiko
A Tiger
Collection the artist

Hiroshige 3rd
Trolley on Ginza
Private collection, New York

Attributed to Takanobu
Circus Scene
Washburn Gallery, New York

Kobayashi Kiyochika
Omaru in Ofuba-town
Ronin Gallery, New York

Hashiguchi Goyo
Bather
Ronin Gallery, New York

Hashiguchi Goyo
Onao-san of Matsuyoshi Inn
Ronin Gallery, New York

Ito Shinsui
Girl Combing Her Hair
Ronin Gallery, New York

Ito Shinsui
Lotus Flowers
Private collection, Tokyo

Kawase Hasui
Kiyosu Bridge, Tokyo
Private collection, Tokyo

Kawase Hasui
Night over Takatsu in Osaka
Ronin Gallery, New York

Yoshida Hiroshi
River View of Hayase
Ronin Gallery, New York

Yoshida Hiroshi
Calm Wind
Ronin Gallery, New York

Onchi Koshiro
Portrait of Mioko
Collection the author

Onchi Koshiro
Abstraction
Collection the author

Hiratsuka Yunichi
Nara Pagoda
Collection the author

Maekawa Sempan
Tanabata Festival
Collection the author

Kawanishi Hide
Kobe
Judah Foundation, Los Angeles

Kawakami Sumio
Arrival of the Portuguese in Japan
Collection the author

Saîto Kyoshi
Chinese Temple, Nagasaki
Judah Foundation, Los Angeles

Munakata Shiko
Disciple of Buddha
Private collection, New York

Tanaka Ryohei
Thatched Roof No. 10
Collection the author

Ikeda Matsuo
Scene with an Angel
Associated American Artists, New York

Okuma Ujihiro
Omura Masujiro
Yasukuni Shrine, Tokyo

Takamura Koun
Old Monkey
National Museum, Tokyo

Takamura Koun
Kusunoki Masashige
Imperial Palace Square, Tokyo

Ogiwara Morie
Woman
National Museum, Tokyo

Takamura Kotaro
Hand
National Museum, Tokyo

Nagare Masayuki
Returning
Stampfli Gallery, New York

Tatsuno Kingo
Nihon Ginko (Bank of Japan), Tokyo

Katayama Tokuma
Akasaka Detached Palace, Tokyo

Okuma Kiho
Diet Building, Tokyo

Yoshida Tetsuro
Central Post Office, Tokyo

Furuhashi Ryutaro
Christ Church, Nara

Sakakura Junzo
Japanese Pavilion, Paris Exposition of 1937

Maekawa Kunio
Tokyo Metropolitan Festival Hall

Maekawa Kunio
Tokyo Metropolitan Festival Hall

Kenzo Tange
Tokyo Olympic Swimming Pool

Kenzo Tange
Tokyo Olympic Swimming Pool (interior)

Yoshimura Junzo
Japan Society, New York

Yoshimura Junzo
Japan Society, New York (interior)

Tomimoto Kenkichi
Plate
Collection the author

Hamada Shoji
Vase
Collection the author

Shibata Zeshin
Lacquer Tray
Collection Alice Boney, New York

Kitaoji Rosanjin
Oribe Jar
Collection the author

Kitaoji Rosanjin
Shino Ware Vessel
Brooklyn Museum

Hamada Shoji
Plate
Collection the author

Kawai Kanjiro
Vase
Collection the author

Hamada Shoji
Vase
Collection the author

Tomimoto Kenkichi
Mingei Style Plate
Collection the author

Arakawa Toyozo
Shino Tea Bowl
Private collection, Tokyo

Fujiwara Kei
Bizen Ware Jar
Collection the author

Kaneshiga Toyo
Bizen Dish
Collection the author

Serizawa Keizuke
Fan with stencil design

Straw Horses from Nagano Prefecture

Modern Folk Art Vessels
from Fukushima Prefecture

Folk Baskets from rural Japan

Iron Kettle from Iwate Prefecture